Postcard History Series

Around
Rocky Mountain
National Park

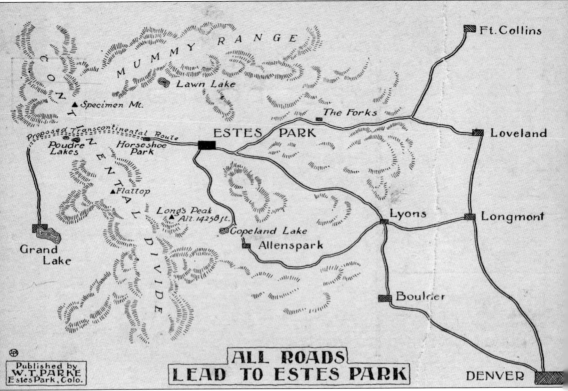

This W.T. Parke postcard was used to promote the relative ease to reach Estes Park from any number of locations. Drawn by Dean Babcock, the map was created prior to establishment of Rocky Mountain National Park in 1915 and shows the proposed location of the transcontinental route, Fall River Road, which was completed in 1920. The back of the card proclaims, "Estes Park—the Playground of Colorado. Best Auto Roads in the State. Try it Once." (Courtesy Bobbie Heisterkamp Collection.)

ON THE FRONT COVER: Guests gather in front of the Elkhorn Lodge on saddle horses provided by the lodge in a c. 1910 postcard by F.P. Clatworthy. The property included a livery stable with access to numerous trails. (Author collection.)

ON THE BACK COVER: Sightseers enjoy a guided tour through Rocky Mountain National Park in open-air buses provided by the Rocky Mountain Parks Transportation Company in a postcard made by the H.H. Tammen Co. around 1921. At the first hint of spring, crews would spend a month or more clearing snow to prepare Fall River Road for its season opening. (Author collection.)

POSTCARD HISTORY SERIES

Around Rocky Mountain National Park

Suzanne Silverthorn

ARCADIA
PUBLISHING

Published by Arcadia Publishing
Charleston, South Carolina

Printed in the United States of America

Library of Congress Control Number: 2015945438

For all general information contact Arcadia Publishing at:
Telephone 843-853-2070
Fax 843-853-0044
E-mail sales@arcadiapublishing.com
For customer service and orders:
Toll-Free 1-888-313-2665

Visit us on the Internet at www.arcadiapublishing.com

Dedicated to my mother, Dian Zillner, who introduced me to world of collecting and encouraged me to pursue my passion

CONTENTS

ACKNOWLEDGMENTS

It was only recently that I became aware of the lasting contributions of my former Grand Lake, Colorado, employers—Bill and Betty Caswell. As a teenager in the 1970s, while I was busy washing dishes and waiting tables at their Golden Spur restaurant, the Caswells were working on a legacy project to help create the Grand Lake Area Historical Society, which, along with the Grand County Historical Association, continues as an important resource to preserve the area history. Across the Continental Divide, the Estes Park Museum and its Friends and Foundation organization have been established as a similar repository. These organizations are supported by dedicated staff members and volunteers who work tirelessly to share their passion about local history and its relevancy. My thanks to many of these individuals who have taken the time to assist with questions and research, including Tim Nicklas, museum director for the Grand County Historical Association, and Kathy Means of the Grand Lake Area Historical Society, as well as Steve Batty, Don Campbell, and Jane Patience Kemp, whose families have been connected with Grand Lake for decades.

Another valuable resource has been the Estes Park Postcard Club, which is a wonderful outlet to meet like-minded collectors. One of its members is Bobbie Heisterkamp, who has acquired one of the largest known collections of Rocky Mountain National Park–area postcards and has graciously loaned some of her favorite images for inclusion in this book. Bobbie's collection is destined to be archived at the Estes Park Museum so that it might be used for research and exhibits and shared with generations to come.

My thanks are extended, also, for help provided by fellow Arcadia author and historian Sybil Barnes. Additional assistance was provided by Jim Detterline, who served as a Longs Peak Supervisory Climbing Ranger until 2009. Jim is an expert on Longs Peak history, having broken the all-time Longs Peak summit record in 2010 with 351 lifetime climbs, surpassing Shep Husted's long-standing record of 350. Special thanks also go to Kelly Cahill, curator of Rocky Mountain National Park.

Appreciation is also extended to Arcadia's Stacia Bannerman for her editorial guidance and, of course, members of my family, who allowed me to give this project my undivided attention.

Every attempt is made to identify the publisher or photographer of each of the postcards used in this publication. All postcards containing a mark on the bottom right corner were produced by Sanborn unless noted otherwise. Most postcards are from the author's collection. Credits are given for images supplied by the Bobbie Heisterkamp Collection, Grand County Historical Association, and Fort Collins Local History Archive.

INTRODUCTION

Long before the nation's 10th national park was established in the Rocky Mountains of Colorado, photographic images showing the rugged landscape of newly surveyed territories of the American West began circulating to settlements east of the Mississippi. The images from the mid- to late 1800s by William Henry Jackson and other skilled photographers were accompanied by first-hand accounts of adventure, opportunity, and an abundance of gold and silver.

While Colorado's mining boom was short-lived, many of the prospectors that had come seeking new fortunes settled into other pursuits. Among the early inhabitants was Joel Estes, who built a cabin and raised cattle around 1859 near the present-day Estes Park, which was platted in 1905. The town, bordering Rocky Mountain National Park, is named in his honor. While Estes's time in the area was brief, Griff Evans took over the property and found that providing food and housing for early explorers was a convenient way to supplement an elusive ranching income. In anticipation of accommodations needed for even more visitors, the Estes Park Hotel was opened in 1877, followed by other hostelries. Across the Continental Divide in Middle Park, former prospector Joseph Wescott arrived in 1867, eventually becoming Grand Lake's first postmaster. And so they came, creating a new presence on lands that had once served as tribal hunting grounds for the Ute, Arapaho, and Cheyenne.

In the 1870s, even more gritty homesteaders arrived and claimed the land as their own, just in time for a surge of wealthy sightseers made possible by the railroads. On the east side of the Continental Divide, rail lines that had been laid in the late 1870s allowed the Colorado and Southern Railway to provide passenger service to the nearby communities of Loveland and Longmont. On the west, the Denver Northwestern & Pacific Railroad was delivering passengers as far as Granby by 1905, while Denver's Union Station became a hub for the major railroads. The possibility of bringing a rail line through the future Rocky Mountain National Park was contemplated as early as the 1880s, when a route was surveyed by the Greeley, Salt Lake & Pacific Railroad. However, the route never materialized due to the engineering and economic difficulties. Roads, therefore, became the great connectors to funnel tourists from the rails to the mountainsides. Transportation pioneers, most notably David Osborn, Freelan Oscar Stanley, Edward L. Berthoud, and Roe Emery provided significant investment in the creation of roads and other infrastructure to make way for the tourists.

The hospitality industry began to hit its stride on the east side of the Continental Divide when F.O. Stanley opened the Stanley Hotel in Estes Park in 1909. The hotel provided a critical transportation link in its use of Stanley Steamer automobiles along narrow wagon roads to connect guests with the train depots. By now, other nearby lodges had been established with

proprietors at the Estes Park Hotel, Stead's Hotel, Elkhorn Lodge, Rustic Hotel, and other lodges welcoming loyal customers that would return in ensuing years.

Photography studios were opened to provide souvenirs to the visitors, including postcards, which were made available when Congress passed the Private Mailing Card Act in 1898. It wasn't until 1907 that users were allowed to write messages on the back of the cards. These divided postcards were mailed by the thousands to friends and families, offering personal endorsements of a trip to the mountains. The Estes Park View Gallery, a storefront on Elkhorn Avenue owned by photographer W.T. Parke, was the first studio to open around 1904. Parke produced and sold postcards of area scenes, many of which are presented in this book. In 1905, photographer Fred Payne Clatworthy opened a storefront in the newly platted Estes Park. His souvenirs were sold for decades, including scenes from 1907, some of which are also presented in the chapters that follow.

Even postcards made from images supplied by American West photographer William Henry Jackson were available for purchase, published by the Detroit Photographic Company, later known as the Detroit Publishing Company. By the 1900s, other postcards of the region were being produced by the H.H. Tammen Company in Denver, one of the largest Western souvenir suppliers in the country, and identified in later chapters as "HHT" postcards. The majority of the postcards in this book are from the Sanborn Souvenir Company of Denver, which began producing real photo postcards of the Rocky Mountain National Park area in the late 1920s. The postcards are marked "Sanborn" on the lower right corner. During his tenure, photographer Harold Sanborn amassed thousands of images showcasing scenes in Colorado, Wyoming, and other Western regions. Son Bill took over the business from the 1950s to the 1980s.

The establishment of Rocky Mountain National Park in 1915 and the ensuing completion of Fall River Road in 1920, and later Trail Ridge Road in 1932, helped provide an economic boost to the tourist trade in Grand Lake, the park's western gateway, which was challenged by limited accessibility before the new roads were built. Additional tourism prospects were born with introduction of the Circle Tour, a 240-mile scenic route created by Roe Emery that brought busloads of guests for overnight stays in Estes Park and Grand Lake beginning in 1921.

When Pres. Woodrow Wilson signed the Rocky Mountain National Park Act designating the nearly 232,000 acres as a national park on January 26, 1915, the Estes Park and Grand Lake communities rejoiced. The years-long lobbying efforts of naturalist Enos Mills, philanthropist F.O. Stanley, and many others had finally come to pass. Their appearance at a dedication ceremony on September 4, 1915, in Horseshoe Park was a proud moment. Now, 100 years later with Longs Peak looming high above, today's 3.2 million annual visitors are sharing the same appreciation for the park's beauty enjoyed all those years ago.

The postcards in this book were selected to chronicle the progression of the development of tourism in the Rocky Mountains from 1900 to 1960. It is a tribute to those that worked tirelessly to provide a welcoming and memorable experience.

One

EARLY TRAVELS

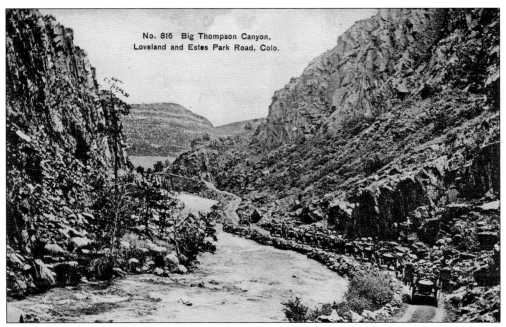

The popularity of a sightseeing trip to the Rocky Mountains of Colorado once rivaled visits to Yellowstone and Yosemite National Parks combined. When these Stanley Steamer touring cars began replacing horse-drawn conveyances, stage routes from earlier days were rebuilt to make way for faster and more convenient access. The motor caravan in this W.T. Parke postcard is escorting tourists to Estes Park from nearby Loveland. (Courtesy Bobbie Heisterkamp Collection.)

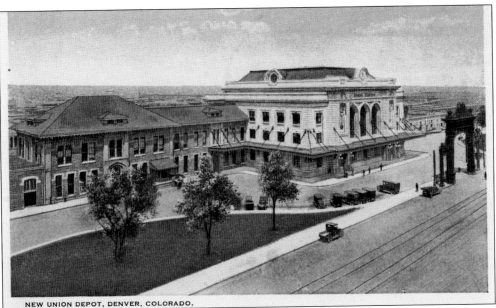

NEW UNION DEPOT, DENVER, COLORADO.

For many adventurers, a national park trip was inspired by patriotism. The See America First campaign was launched by the railroads to provide sightseeing alternatives for wealthy Easterners in lieu of European travels. Following the establishment of Rocky Mountain National Park in 1915, Denver's Union Station became the primary gateway to America's newest national park. When this postcard was produced, the station was providing service for six major railroads.

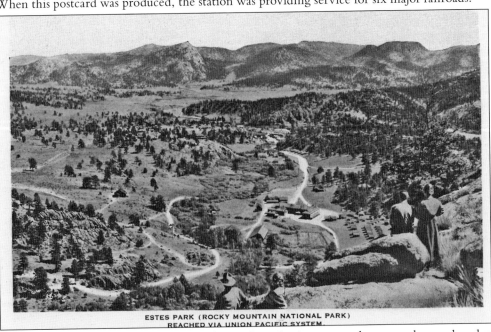

ESTES PARK (ROCKY MOUNTAIN NATIONAL PARK)
REACHED VIA UNION PACIFIC SYSTEM.

Travel pamphlets issued by the railroads featured captivating scenes that were also produced as postcards. An example is this pictorial card from the Union Pacific System that touts the beauty of a side trip to Estes Park and Rocky Mountain National Park. Building on the momentum of the See America First campaign, the railroads developed the slogan "Playground of the World" to describe the area.

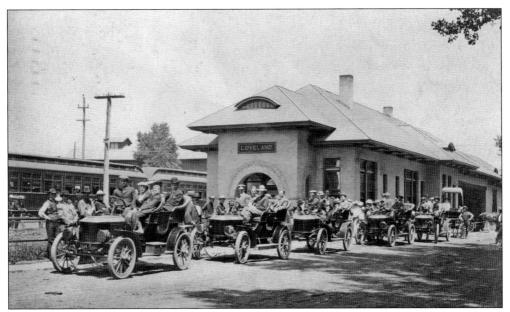

The Colorado & Southern Railway Company provided passenger service to the nearby communities of Loveland and Longmont on rail lines that had been laid in the late 1870s. Passengers disembarked at these depots to begin their side trips to Estes Park. This Clatworthy postcard from 1907 shows the Loveland depot and a fleet of Stanley Steamer touring cars that were used to complete the trip. (Courtesy Bobbie Heisterkamp Collection.)

A popular route for the auto-stage passengers was through the Big Thompson Canyon, which connected roads from Fort Collins and Loveland on the east to Estes Park on the west. The road provided new business opportunities, including the Loveland–Estes Park Transportation Company, which offered daily sightseeing trips using its new line of Stanley Steamers. This 1907 Clatworthy postcard shows a canyon outing in front of the Forks Hotel at Drake.

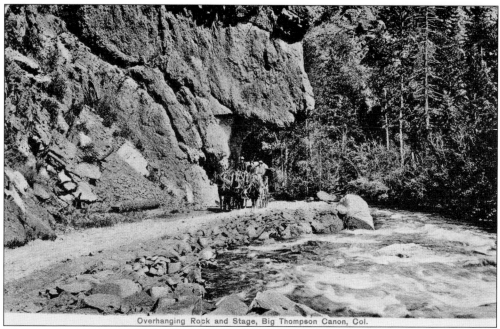

Overhanging Rock and Stage, Big Thompson Canon, Col.

The first road through Big Thompson Canyon was a single-lane route initially used by horses and stages, as shown on this 1907 Clatworthy postcard. The road was completed in the early 1900s using portions of primitive sections built in prior years. For a time, the narrow road was shared by both horse-drawn conveyances and motorized vehicles. (Courtesy Bobbie Heisterkamp Collection.)

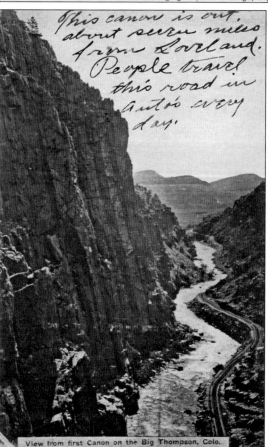

This canon is out, about seven miles from Loveland. People travel this road in auto's every day.

View from first Canon on the Big Thompson, Colo.

For sightseers, one of the noted geological features in the Big Thompson Canyon is the Narrows, located at the mouth of the canyon near Loveland as pictured on this P.C. Company postcard view mailed in 1911. This is a two-mile stretch where the width of the canyon is narrowed while the river makes a series of tight turns on its way out of the mountains towards the plains.

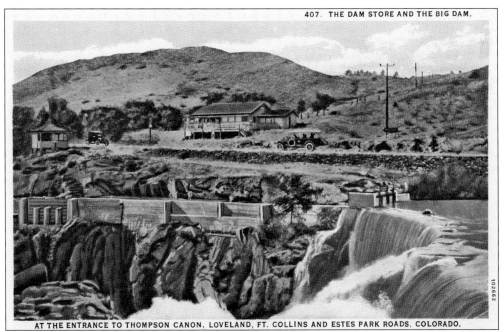

407. THE DAM STORE AND THE BIG DAM.

AT THE ENTRANCE TO THOMPSON CANON, LOVELAND, FT. COLLINS AND ESTES PARK ROADS, COLORADO.

With arrival of the automobile, tourist stops quickly gained popularity along the Big Thompson Canyon. Most noteworthy is the Dam Store, shown in this Sanborn card, situated at the east entrance. It began as a concession shack around 1906 and has had numerous owners and at least two relocations in its long history. The new locations and associated expansions improved the souvenir store's visibility following realignments to the canyon's entrance.

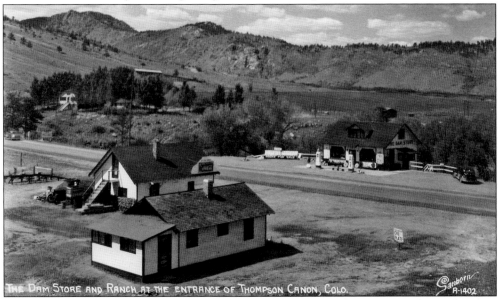

THE DAM STORE AND RANCH AT THE ENTRANCE OF THOMPSON CANON, COLO.

Promoted as the "best store by a dam site," the Dam Store has survived horrific disasters, including the historic Big Thompson Flood of July 31, 1976, in which many lives, homes, businesses, roads, and utilities were lost. The destruction was repeated in 2013, when another massive flood swept through the canyon. The store has remained a favorite stopping point for visitors on their way to Rocky Mountain National Park.

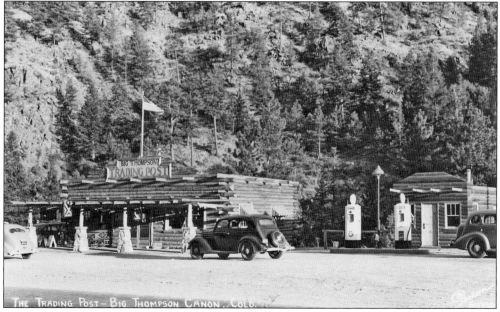

This 1940s postcard pictures the Big Thompson Trading Post, which was typical of the businesses that operated in the canyon. Gasoline pumps are shown alongside the souvenir shop, which sold curios, Native American souvenirs, and locally produced cherry cider. Tucked between the canyon walls were various groupings of motels, cabin courts, and even small communities. The landmark business, operating as Big Thompson Indian Village, was destroyed by the 2013 flood.

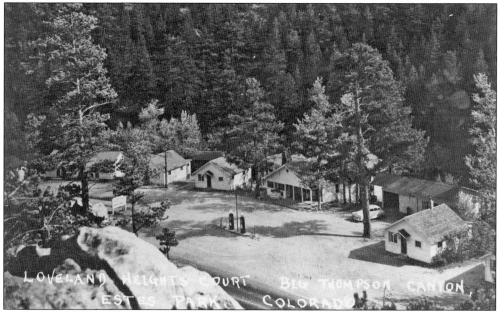

Loveland Heights Cottages has been a familiar sight in the Big Thompson Canyon. It includes one of the older cabins on the upper Big Thompson River, built around 1900. The property contains more than a dozen cottages and remains in operation today after surviving the historic flood in 2013. This vintage postcard shows the cottages nestled among pine and aspen trees in a view that looks similar today.

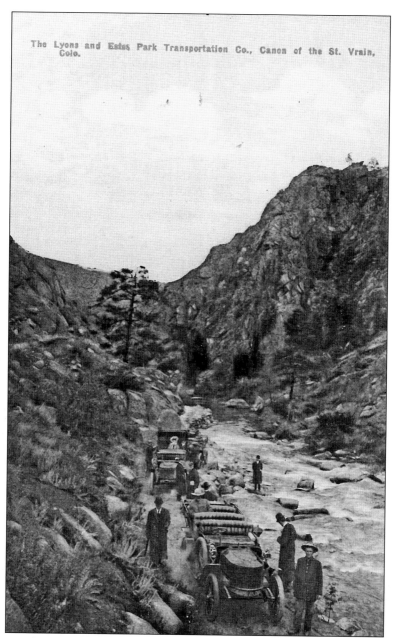

The Lyons and Estes Park Transportation Co., Canon of the St. Vrain, Colo.

Many train travelers stopping in Longmont and Lyons were escorted to Rocky Mountain National Park by the Estes Park Transportation Company, which was formed in 1908 by Freelan Oscar "F.O." Stanley as he was completing construction of his grand hotel in Estes Park. The St. Vrain route to Estes Park included both north and south passageways. The junction was in Lyons, which became known as the "Double Gateway to the Rockies." In this c. 1910 HHT postcard, drivers and guests pose for a photograph along the narrow St. Vrain Canyon in steamer models that carry the Stanley name. With the St. Vrain River located along the route (now State Highway 7), the steamers could be conveniently refilled with water. F.O. Stanley and his twin brother, Francis Edgar, invented the Stanley Steamer in the late 1890s in Massachusetts. Production continued into the early 1920s under various ownerships.

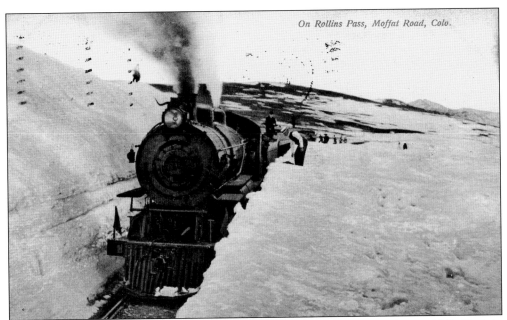

Passenger train service reached the western side of the Continental Divide at Middle Park in 1905 with completion of a line built by David Moffat of the Denver Northwestern & Pacific Railroad. The Moffat Road route extended 255 miles from Denver west to Craig, Colorado. Made in Germany, this postcard was mailed in 1909 and shows the most difficult part of the route, Rollins Pass, at an elevation of 11,660 feet.

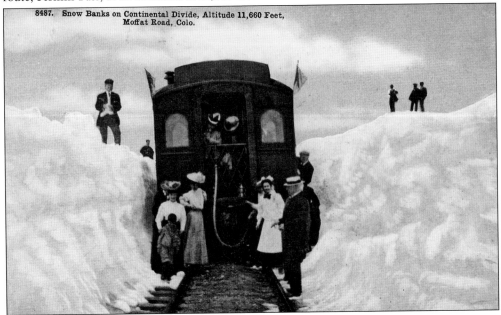

8487. Snow Banks on Continental Divide, Altitude 11,660 Feet, Moffat Road, Colo.

Much of the Moffat route followed the Boulder Wagon Road, which had been in use since 1874. The rail line was intended to reach Salt Lake City, but when financing fell short, the line began promoting round-trip sightseeing trips originating from Denver. The excursions traveled through snow cuts as high as 30 feet, as illustrated on this 1910 postcard of Rollins Pass, also called Corona Pass, published by Great Western.

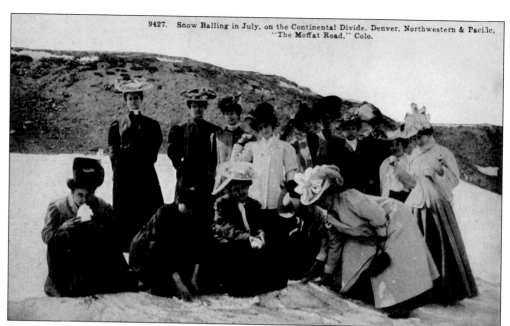

9427. Snow Balling in July, on the Continental Divide, Denver, Northwestern & Pacific, "The Moffat Road," Colo.

A popular sightseeing trip on the Moffat Road was a three-hour ride from Denver to "the top o' the world" at Corona, on the Continental Divide. A dining station was located here, equipped to serve meals to 150 passengers at a time. This c. 1910 postcard shows a group of well-dressed ladies making snowballs while enjoying a visit in July. Passengers were returned to Denver by 5:30 p.m.

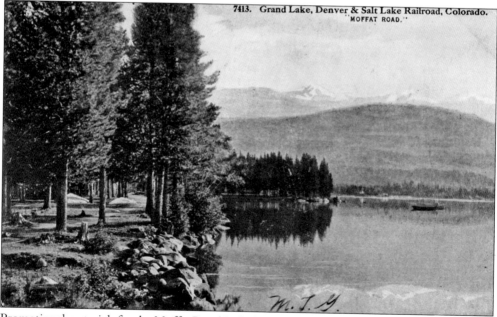

7413. Grand Lake, Denver & Salt Lake Railroad, Colorado. "MOFFAT ROAD."

Promotional materials for the Moffat Road included this HHT postcard mailed in 1916 showing Grand Lake and its surroundings. The railroad's publicity machine noted that Grand Lake was destined to become one of the most popular summer resorts in the United States. Passengers bound for Grand Lake disembarked at the train stop in nearby Granby and arranged for a 16-mile stage ride for the remainder of their trip.

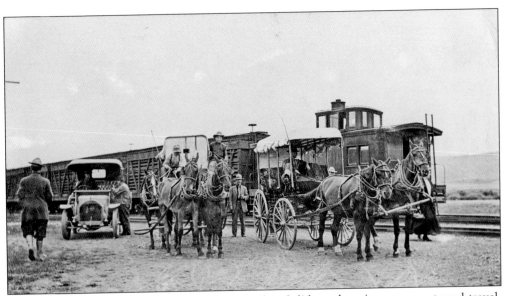

While the Denver Northwestern & Pacific Railroad did much to improve westward travel, stagecoaches and wagons were the primary means of getting around in the decades that preceded the automobile. This postcard shows the convergence of all three forms of transportation at the Granby train depot. Included are outfits from the Tovey Stage Line, which transported guests between Granby and Grand Lake until 1927. (Courtesy Grand County Historical Association.)

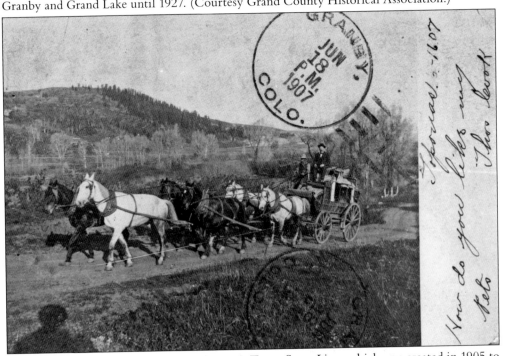

This postcard shows another view of the L.M. Tovey Stage Line, which was created in 1905 to service railroad passengers headed to Grand Lake. Automobile travel began to take hold in 1913, when the first license plates were issued in the county. Until then, horse-pulled stages were commonly used throughout Middle Park with additional routes from Georgetown, Empire, and Idaho Springs. (Courtesy No. H11154 Fort Collins Local History Archive.)

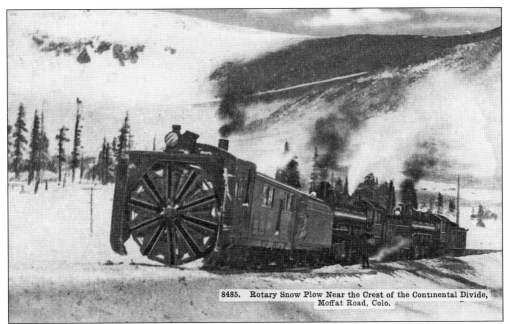

8485. Rotary Snow Plow Near the Crest of the Continental Divide, Moffat Road, Colo.

Despite the Moffat Road's herculean efforts to keep the tracks clear of snow by using rotary snowplows and constructing wooden snow sheds, the elements eventually took their toll on the railroad. Passengers found themselves stranded for days at a time during severe snowstorms on Rollins Pass. Engineers eventually recommended construction of a tunnel to eliminate the harsh conditions. This postcard was mailed in 1914.

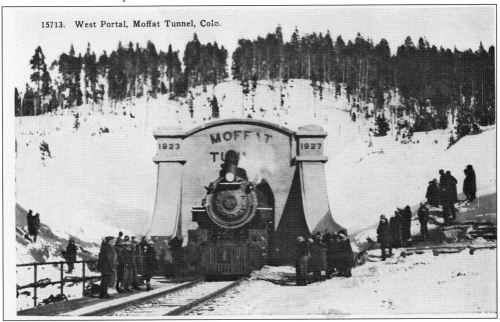

15713. West Portal, Moffat Tunnel, Colo.

Construction of the Moffat Tunnel under the Continental Divide was considered one of America's great engineering feats when this HHT postcard was produced following the tunnel's opening in 1928. The new tunnel replaced the Rollins Pass route. At more than six miles, it was the longest railroad tunnel in the western hemisphere. The tunnel is still in use today.

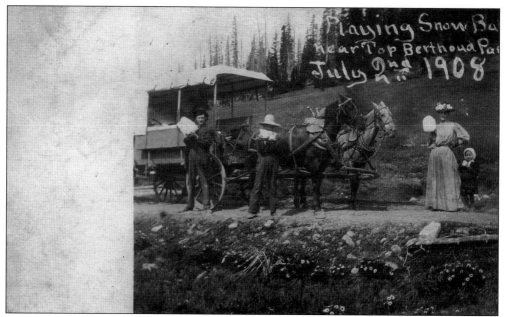

Berthoud Pass has connected settlements in Middle Park and Clear Creek Canyon since its opening as a stagecoach route in 1874. Stage stops could be found on the west side of the pass near the present-day Winter Park, as well as the Fraser and Tabernash areas and south of Granby. This postcard dated July 2, 1908, shows travelers posing with snowballs near the summit of Berthoud Pass.

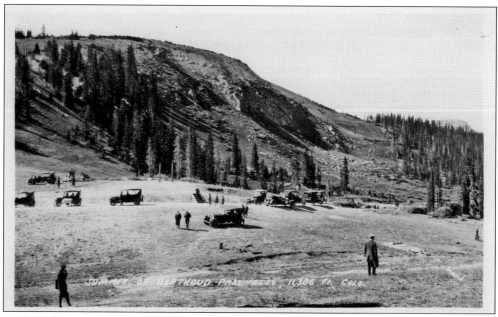

By the early 1920s, the Berthoud Pass stage route was reconstructed and widened to accommodate the growing demands of automobile travel, which had grown to an estimated 400,000 vehicles by 1918. This postcard shows the popularity of the route as motorists gather at 11,306 feet. The road was open during the summer and became impassible following sudden snowstorms. (Courtesy Bobbie Heisterkamp Collection.)

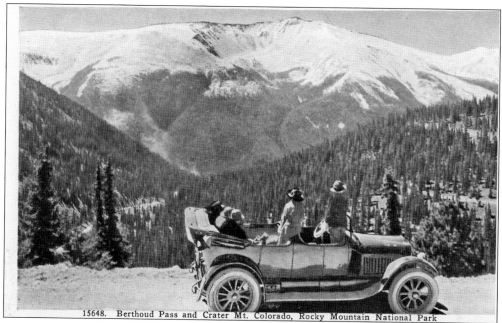

15648. Berthoud Pass and Crater Mt. Colorado, Rocky Mountain National Park

Roe Emery's Circle Tour used this route beginning in 1921 to transport sightseers back to Denver after a guided automobile tour through Rocky Mountain National Park. The tour crossed the Continental Divide twice, once on Fall River Road and again at the top of Berthoud Pass. This HHT postcard shows a group of Circle Tour guests enjoying views of Crater Mountain on Berthoud Pass.

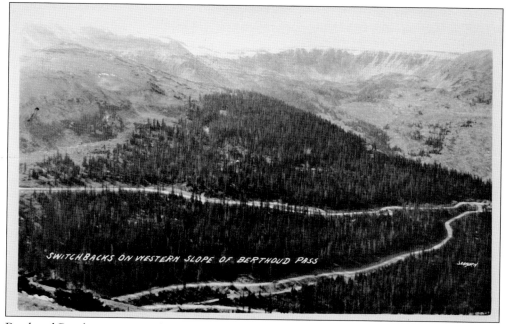

SWITCHBACKS ON WESTERN SLOPE OF BERTHOUD PASS

Berthoud Pass became part of the US 40 Victory Highway route in 1926 and has remained an important connection to the western side of Rocky Mountain National Park. This postcard shows the various switchbacks on the road. The western entrance to Berthoud Pass begins a few miles east of the Winter Park Resort, established in 1940.

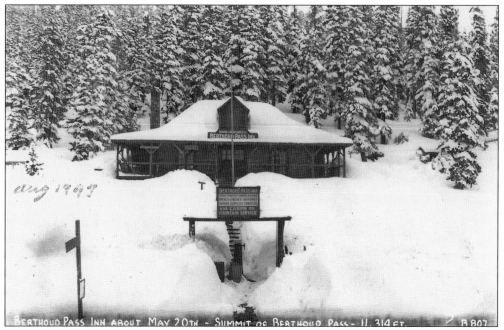

The Berthoud Pass Inn was built at the summit in the mid-1920s to provide food, souvenirs, gas, and sleeping rooms. This postcard shows the inn, at an elevation well above 11,000 feet, as it appeared in late May surrounded by the winter snowfall. The building was struck by lightning later in the decade and in the ensuing years was replaced by other facilities, including a ski lodge.

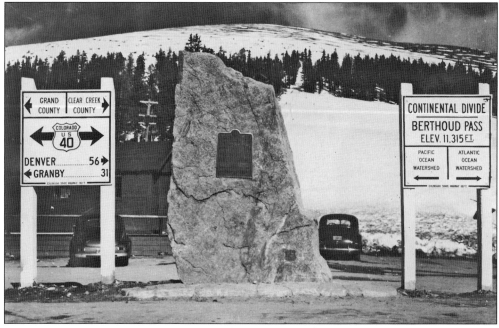

After years as a summer-only roadway, Berthoud Pass opened for its first winter season in 1931. Six years later, skiers began using a rope tow to reach the summit, and by 1948, a ski lift had been installed. This early-1950s card shows a Continental Divide monument marker at the top of the pass as well as views of the new ski operation. The ski lifts were removed in 2003.

Two

Lost Lodges, Hotels, and Ranches

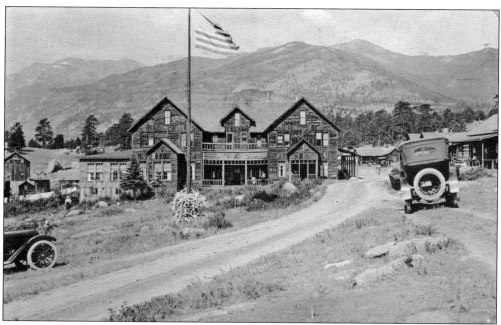

Abner Sprague homesteaded land in the 1870s that eventually became the informal settlement of Moraine Park and later part of Rocky Mountain National Park. The family supplemented their ranching operations by building a cluster of cabins and later a log hotel. In the early 1900s, Sprague added partner James Stead, who eventually assumed ownership of the resort. This postcard of Stead's Hotel was mailed in 1923. (Courtesy Bobbie Heisterkamp Collection.)

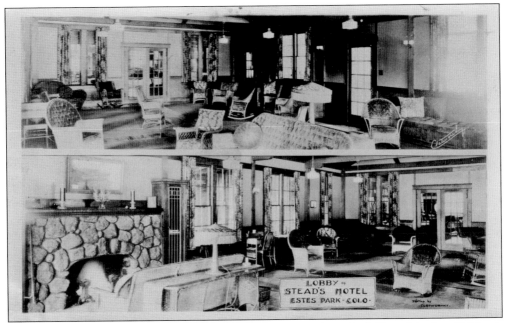

This early postcard by Clatworthy combines two images to show the lobby of the Stead's Hotel. A large stone fireplace serves as the centerpiece of the room, which is furnished with wicker chairs, rockers, and lamps from the period. The decor was changed to a Western theme in later years. (Courtesy Bobbie Heisterkamp Collection.)

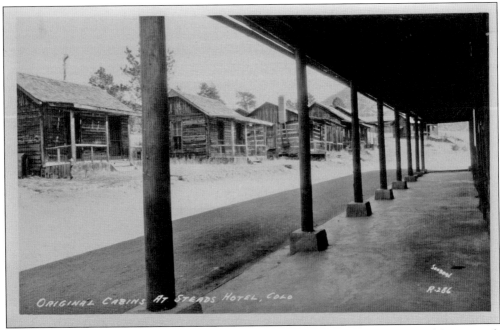

The early cabins at the Stead's property built by Abner Sprague are shown in this postcard. The tiny cabins were constructed with two entries from the front porch. The growing demand for accommodations soon created the need to build additional lodging quarters and associated amenities. (Courtesy Bobbie Heisterkamp Collection.)

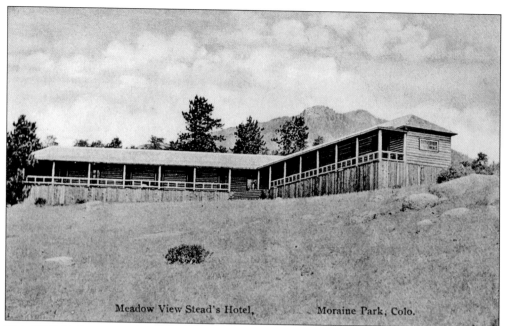

Meadow View Stead's Hotel, Moraine Park, Colo.

This W.T. Parke postcard shows one of the new lodge additions called Meadow View. Stead's was advertised as one of the best-known hostelries in Rocky Mountain National Park, with all the conveniences of a modern hotel. Following the death of James Stead in 1931, it was operated by a family member, W.G. Lewis. In the 1950s, the property was run by Sprague family member Edgar M. Stopher.

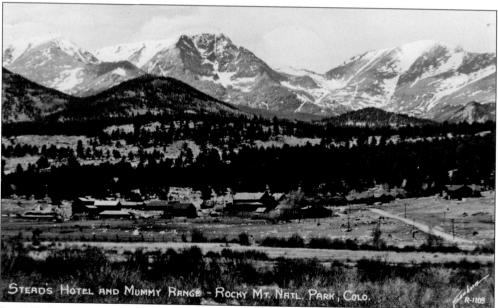

Stead's Hotel and Mummy Range - Rocky Mt. Natl. Park, Colo.

By 1935, the Stead's property could accommodate 200 guests. It continued as a working ranch and grew to include more than 40 buildings and a variety of recreational offerings, including horseback riding, fishing, square dancing, tennis, swimming, and golf. Operations continued until 1962, when the ranch was sold to the National Park Service. The buildings were removed the following year. This postcard was mailed in 1938. (Courtesy Bobbie Heisterkamp Collection.)

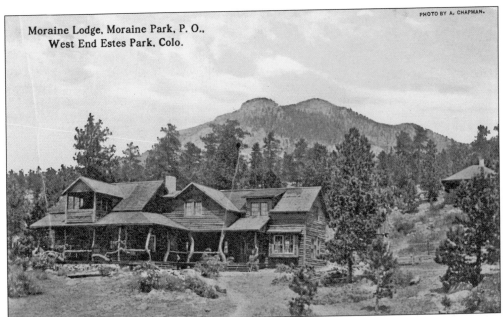

Moraine Lodge, Moraine Park, P. O.,
West End Estes Park, Colo.

Moraine Park was bustling with activity upon the arrival of Imogene Greene McPherson around 1902. She opened her Moraine Lodge later in the decade and promoted it as a "resort of high standards." This Curt Teich Company postcard shows one of the buildings on the grounds described in an early booklet as "Lodge No. 2." A main lodge, cabins, tent houses, stables, an automobile barn, and a recreation hall were also built.

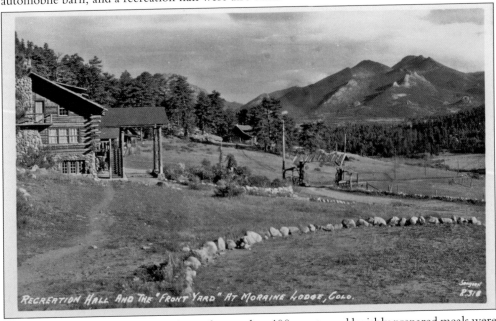

RECREATION HALL AND THE "FRONT YARD" AT MORAINE LODGE, COLO.

By the late 1920s, Moraine Lodge housed more than 100 guests, and lavishly prepared meals were served using fresh ingredients from the garden, poultry yard, and dairy. Following McPherson's death in 1928, the property was eventually acquired by the government. The lone structure that remains today is the recreation hall, built in 1923. It has since been renovated and is used as an interpretive center. (Courtesy Bobbie Heisterkamp Collection.)

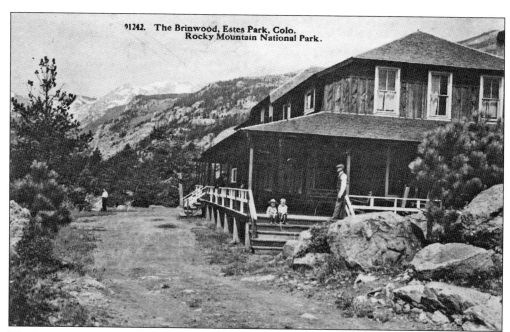

91242. The Brinwood, Estes Park, Colo.
Rocky Mountain National Park.

The Brinwood Hotel, located in Moraine Park, was built in 1911 by Charles Reed. This HHT postcard shows the main building, which included a dining room and lounge on the first level and guest rooms above. The hotel was purchased by the government in the early 1930s. The purchase agreement included an arrangement that allowed the Brinwood to operate for more than a dozen more years before it was removed.

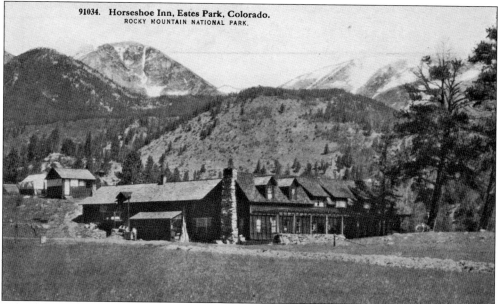

91034. Horseshoe Inn, Estes Park, Colorado.
ROCKY MOUNTAIN NATIONAL PARK.

The Horseshoe Inn was built in 1908 on land acquired by Willard Ashton. It was located on the west end of Horseshoe Park along Fall River Road. After an ownership change in 1915, operations continued until 1931, when it became the first of the private inholdings to be acquired and removed by the National Park Service. This HHT postcard shows the main lodge building and other structures on the hillside.

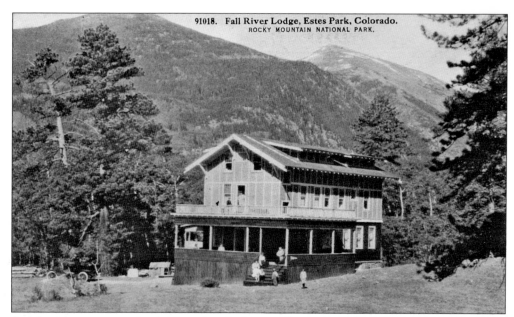

Another property operating in Horseshoe Park was Fall River Lodge and Ranch, opened in 1915 by homesteaders Dan and Minnie March. It was situated across the road from the Horseshoe Inn near the site where various dignitaries came together for the dedication of Rocky Mountain National Park on September 4, 1915. In this HHT postcard, children and adults have gathered on the front steps and balcony to pose for this photograph.

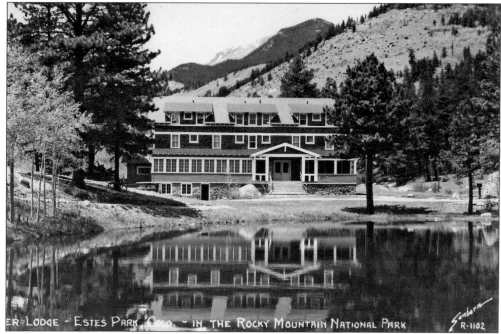

The main building at Fall River Lodge was expanded to increase capacity as shown in this postcard view. The grounds included a man-made fishing pond, recreation hall, and stables. The lodge continued to house guests until the 1950s, when it was acquired by the park service. The buildings were later removed and the pond was drained to return the property to its original state.

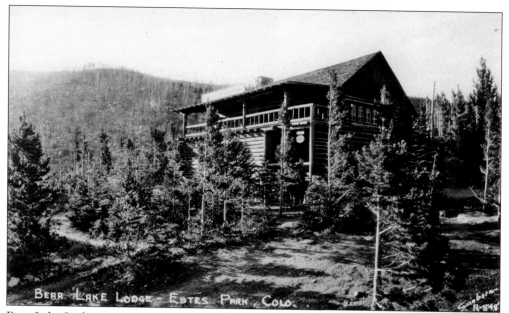

Bear Lake Lodge was once the home of Camp Haiyaha, a private camp for boys operated in the 1920s by Frank H. Cheley on land leased by Frank Byerly. This building was the lodge headquarters for the camp's Bear Lake Trail School, which took in a select group of boys each season from upper-class families. Byerly was the government permit-holder for commercial operations on the property. (Courtesy Bobbie Heisterkamp Collection.)

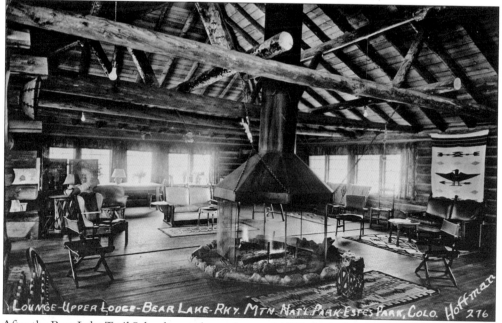

After the Bear Lake Trail School was relocated around 1927, the Bishop family assumed operation of the resort. Bear Lake Lodge included two main buildings, known as the lower lodge and upper lodge, plus cottages and a stable. After the Bishop family lease expired in 1958, the upper lodge, as shown in this Hoffman postcard, was relocated to a nearby private campground. The other buildings were removed.

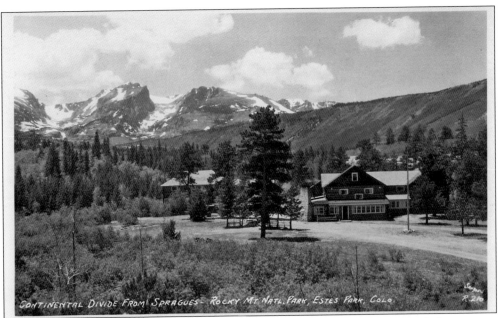

Abner Sprague returned to the tourism business around 1914 when he expanded a summer home he had built in Glacier Basin on land leased from the government. The site was accessed from Bear Lake Road and was initially called Glacier Basin Lodge. This postcard shows the main lodge, which was renamed Sprague's Hotel. Several cabins were added to the property; altogether, the resort could accommodate over 40 guests.

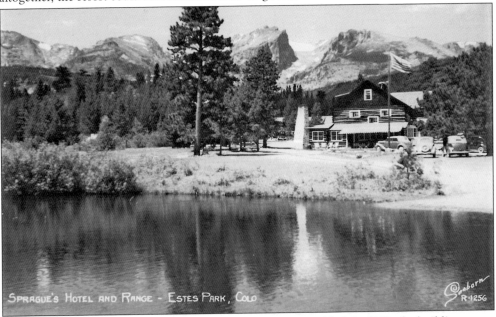

This postcard shows Sprague's Hotel after a fishing lake was added. In 1932, the buildings were sold to the National Park Service in an arrangement that allowed Abner Sprague to continue operating the lodge under a 20-year lease. In the early 1950s, an extended lease was assumed by family member Edgar Stopher, who ran the resort until the late 1950s. The buildings were later removed, but the lake remains.

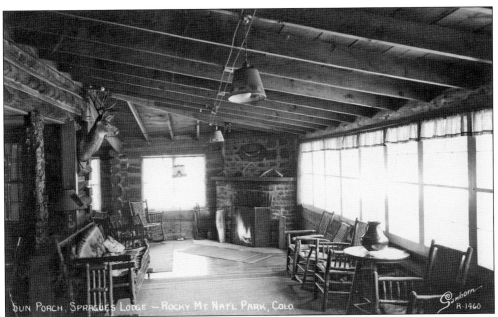

The sunporch at Sprague's Lodge included a bank of windows to take in the views, while a fireplace kept visitors warm on chilly days. The sender of this postcard writes, "Am sitting in front of the fireplace. Why can't I have more time in such a place? Just had dinner. Square dancing tonight. I'm going to save my dimes and have a couple of weeks here next summer."

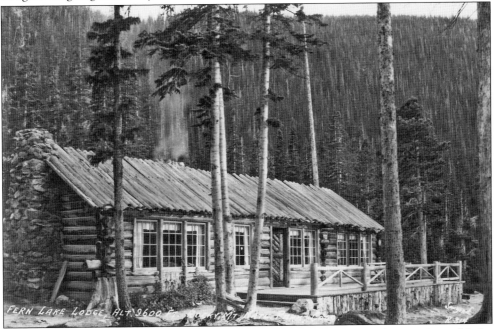

Fern Lodge, elevation 9,600 feet, was one of the more remote accommodations. Accessible by hiking or horse trail, the lodge was built at Fern Lake around 1910 by William J. Workman. Additional buildings were added as the property changed ownership. While most lodges remained closed during the winter, Fern Lodge was a popular winter destination, hosting ski and snowshoe outings sponsored by the Colorado Mountain Club.

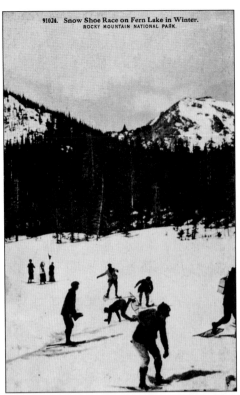

This HHT postcard was issued in the 1920s to promote winter activities at Fern Lake in Rocky Mountain National Park. The card notes the park's contributions in adding to the fame of Colorado as a winter resort: "Until recently winter sports were more or less a secondary matter with the tourist visiting Colorado, but now lovers of winter sports journey from all over the world to participate." Activities included skiing, skating, and tobogganing.

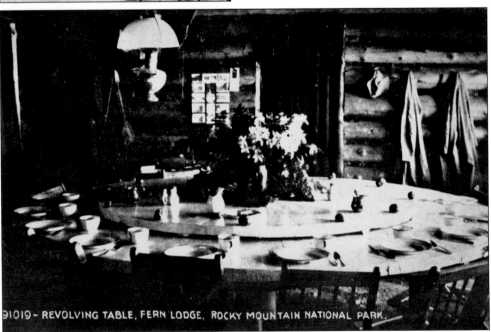

The interior of Fern Lodge featured this novel revolving table, where guests were instructed to rotate the top to reach the condiments independently so as not to impose on other diners. The knobs that were used to turn the table were made of potatoes. The postcard was published by HHT. (Courtesy Bobbie Heisterkamp Collection.)

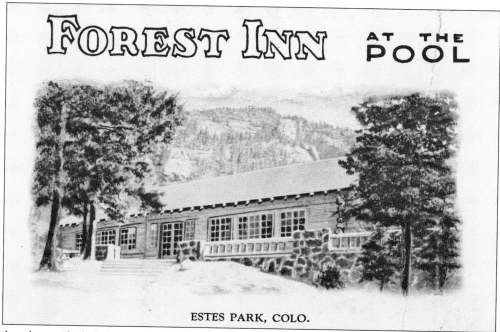

Another trailside lodge was Forest Inn on the Fern Lake Trail along the Big Thompson River. This building opened around 1929 after fire destroyed an earlier structure, causing the owners, Frank and Fannie Tecker, to operate mostly with tents until the new lodge was built. The four-panel postcard by Curt Teich includes a description of the inn and area activities.

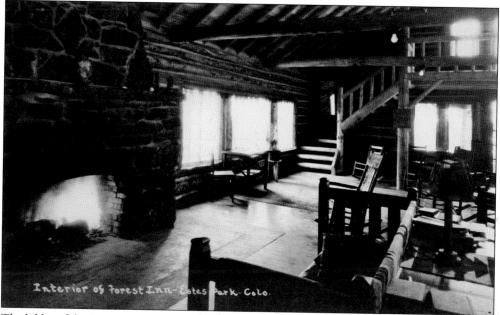

The lobby of the Forest Inn included a large stone fireplace with Mission-style chairs and tables. Fresh eggs and vegetables were packed in from the owner's ranch and served in the dining room. The inn touted all the privileges of a hotel and all the freedom of camp life. At an elevation of 8,500 feet, lakes, streams, and mountains were within easy walking distance. (Courtesy Bobbie Heisterkamp Collection.)

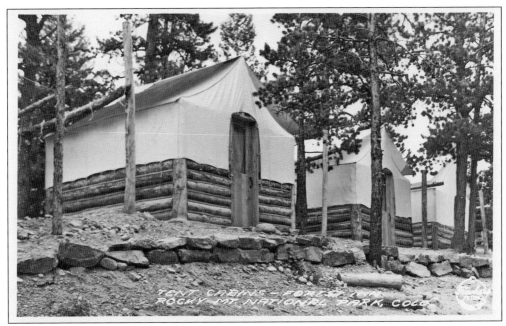

Sleeping quarters at Forest Inn were available in tent cabins like these or log cabins that were equipped with stoves. Both had electric lights. The lodge was operated during the summers, from mid-June to mid-September. The Teckers ran the resort until the early 1950s, when they sold the property to the National Park Service. The buildings were removed later in the decade.

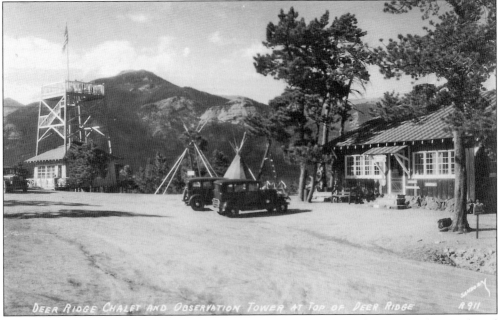

After homesteading property at Deer Ridge Junction, where roads from Horseshoe Park and Beaver Meadows would later intersect, photographer Orville W. Bechtel opened a small tourist stop around 1920 to sell postcards and refreshments. The Deer Ridge Chalet business grew from a single building to a large gift shop, cabins, and a 50-foot observation tower. The tower was built in the mid-1930s by a new owner, Gustave Schubert.

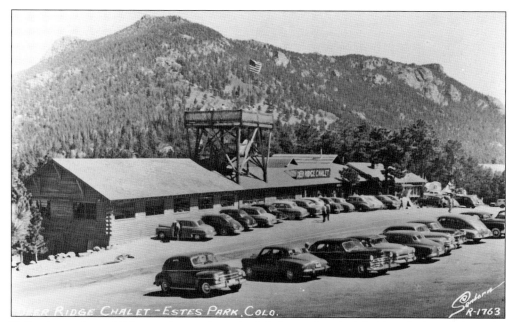

Following various additions and expansions, the Schuberts advertised the Deer Ridge Chalet as the largest souvenir gift shop in the United States. The grounds included overnight accommodations, a restaurant, stables, gas station, and the ever-present observation tower. This postcard was mailed in July 1952 from a guest who had just arrived and was getting ready to eat dinner on "top of the mountain."

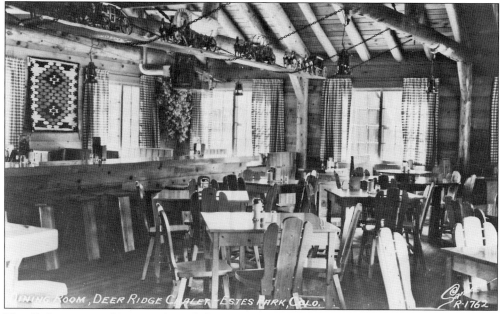

The dining room of Deer Ridge Chalet was furnished with tables and chairs made of rustic pine. A shelf beneath the ceiling adds to the Western decor with displays of horse teams pulling covered wagons and stagecoaches. The business flourished until the property was acquired by government condemnation in 1960 to make way for road improvements. Many of the buildings were relocated and found new uses at other sites.

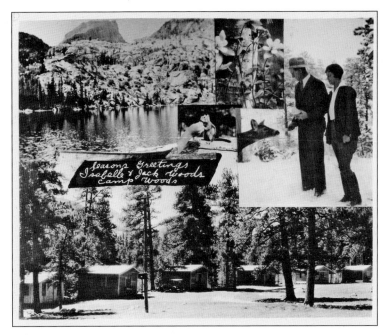

Charles Howard "Jack" and Isabelle Woods operated a group of cabins in Tuxedo Park near the original Big Thompson Entrance Station in the early 1920s. The Camp Woods business included a dining hall and about a dozen cottages that are pictured on this greeting card issued by the couple. In the early 1930s, the camp was acquired by the park service, and the buildings were eventually removed.

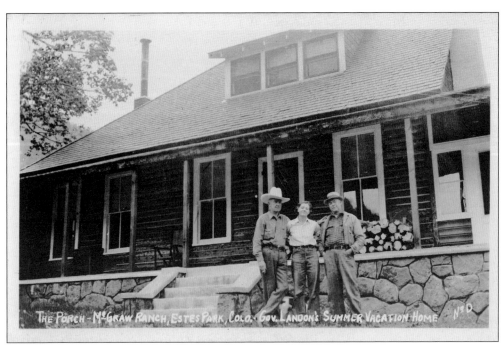

John and Irene McGraw acquired a working cattle ranch around 1909. Located northeast of Estes Park in the Cow Creek Valley, it became a guest ranch by the 1930s after a half-dozen guest cabins were built. McGraw Ranch soon became a favorite vacation spot for Kansas governor Alfred "Alf" Landon, who served two terms as governor and was best known as the Republican Party's 1936 nominee for president.

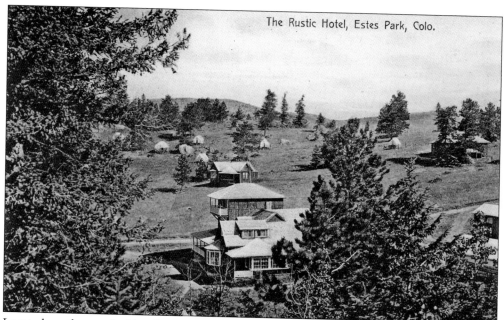

The Rustic Hotel, Estes Park, Colo.

Located on the north side of Estes Park, the Rustic Hotel opened around 1901. It was built by Shepherd "Shep" Husted and a partner on land Husted homesteaded in the 1890s. A noted mountain guide, forest ranger, and proponent of the creation of Rocky Mountain National Park, Husted turned the business over to his partner around 1907 to concentrate on guiding and lecturing activities. The postcard is from W.T. Parke.

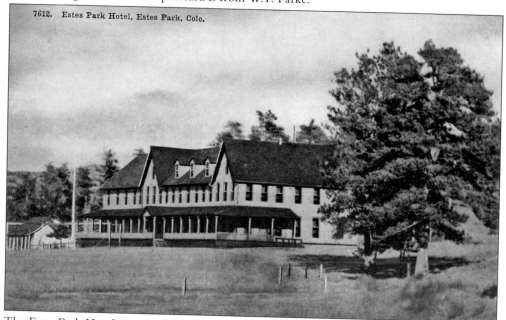

7612. Estes Park Hotel, Estes Park, Colo.

The Estes Park Hotel was the first property to be operated exclusively for guests. Constructed along what is now Fish Creek Road, the luxury hotel opened in 1877. It was financed by the Earl of Dunraven, a wealthy Englishman who acquired 6,000 acres of surrounding land to develop a hunting resort. While Dunraven's grander plans never materialized, the hotel was successful until it was destroyed by fire in 1911.

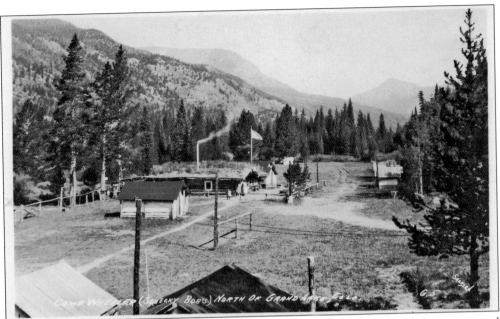

Camp Wheeler was one of the early guest ranches. Located north of Grand Lake, it was operated by Robert L. Wheeler, who homesteaded the 160-acre property in 1907. A year later, he began accommodating guests who were taking guided trips along an old trail between Grand Lake and Estes Park. Wheeler affectionately called his place "Hotel de Hardscrabble," while others referred to the property as "Squeaky Bob's," utilizing Wheeler's nickname.

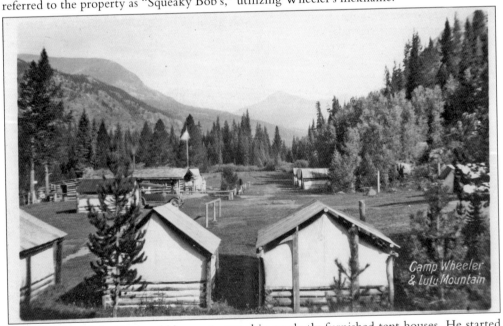

Wheeler's Hotel de Hardscrabble guests stayed in modestly furnished tent houses. He started in 1908 with four tents that quickly grew to 20 by the next year. While the lodging was primitive, it was Wheeler's home-cooked meals and his entertaining tales that won his guests over. Nicknamed for his peculiar voice, "Squeaky Bob" operated the resort until around 1926, when it was sold to Lester A. Scott.

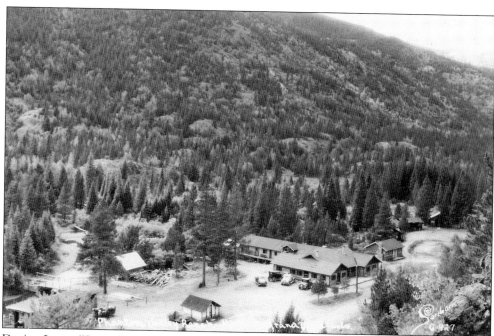

During Lester "Scotty" Scott's ownership, the name of the resort was changed to Phantom Valley Ranch as a tribute to the spirits of past inhabitants of the Never Summer Range. Soon, the tent houses were removed, and a new lodge was built along with cabins and other buildings that are pictured on this 1930s postcard. A bridge spanning the North Fork of the Colorado River is located on the left.

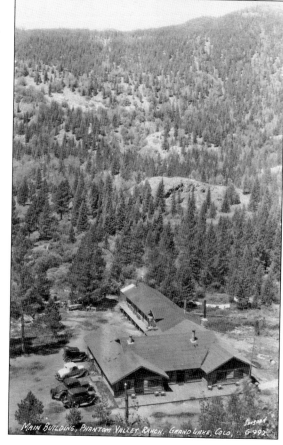

This is a closer view of the main building at Phantom Valley Ranch, showing the L-shaped configuration of the lodge and a mix of touring cars. Guests left their automobiles behind to enjoy scenic horseback rides, hiking, and fishing. By now, access to the ranch had become easier with improvements to area roads.

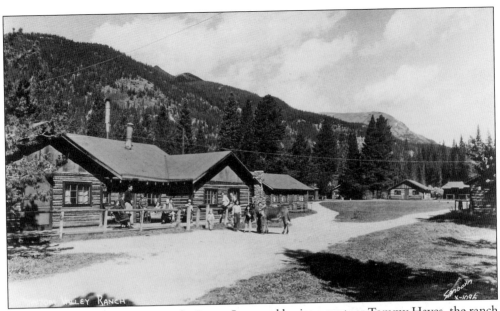

After about 15 years of operation by Lester Scott and business partner Tommy Hayes, the ranch was acquired by Irwin S. Beattie in the early 1940s. The Phantom Valley Ranch name was retained, and a marketing slogan was introduced—"Where the Trails Meet the Sky." Fifteen cabins for 60 guests formed a horseshoe beyond the lodge. A barn and corral were located across the river where 40 horses were stabled.

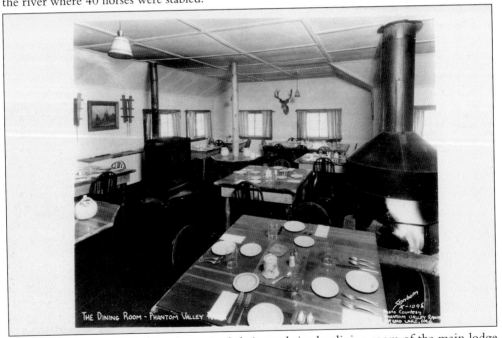

Guests of Phantom Valley Ranch received their meals in the dining room of the main lodge building, where dinners were "tastefully served with full regard for healthy mountain appetites," according to a mailing from the 1940s. This postcard uses a photograph supplied by the guest ranch in the 1930s that was reprinted on materials in later years. Fresh pasteurized milk and cream were delivered daily.

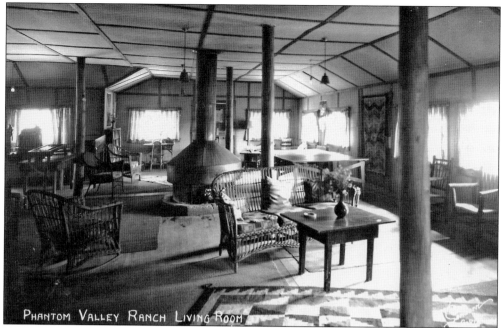

This 1930s postcard shows the interior of the main lodge building at Phantom Valley Ranch furnished with wicker and hickory seating. Entertainment included Sunday-evening buffets and programs, a weekly ranger naturalist talk, square dances, a children's playground, and a variety of half-day and all-day trail rides along National Park–maintained trails to interesting destinations such as Lake of the Clouds, Hell's Hip Pocket, and Thunder Pass.

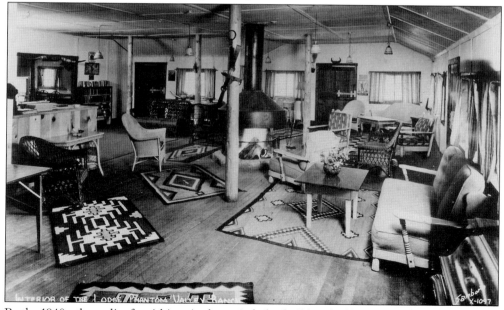

By the 1940s, the earlier furnishings in the main lodge building had been replaced with a modern ranch-style sofa and chairs. Rates in 1946 were as low as $7.50 a day per person or $49 a week. The property was purchased by the National Park Service in 1960. The buildings were removed as part of the Mission 66 program.

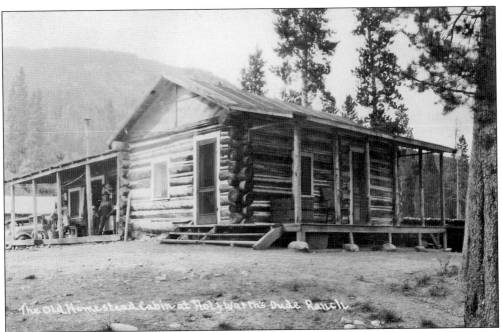

John G. and Sophia Holzwarth began welcoming guests to their Holzwarth Trout Lodge around 1919 after homesteading the ranch in 1917. Located 10 miles north of Grand Lake, it was intended to be a cattle ranch, but when John suffered a debilitating injury, the focus shifted to tourism. This postcard, mailed in 1931, shows the homestead cabin, which had been expanded to become the central gathering place for summer vacationers.

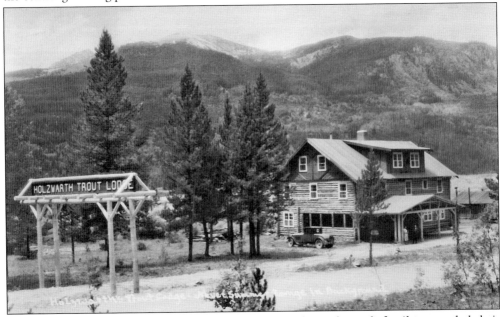

As their hospitality business became more promising, the Holzwarth family expanded their dude ranch operation to a more prominent roadside location on acreage they had purchased in 1918. The facilities included a three-story lodge that was built in 1929, as shown on this 1930s postcard. Son Johnnie took over the business in 1932.

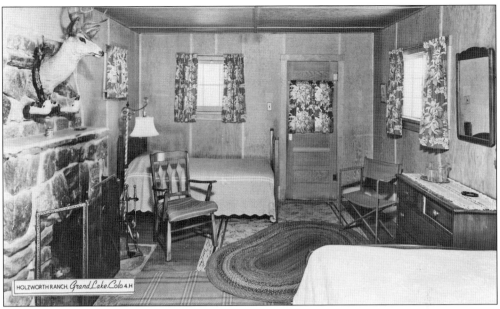

Pamphlets created to promote the Holzwarth Ranch describe the lodging accommodations as "charmingly furnished." This postcard shows the interior of a guest cabin that includes two beds, a dresser, chairs, and a wood-burning fireplace with a trophy deer above. Animal mounts made from local wildlife hunts were prevalent throughout the ranch. They were fashioned by John Sr., who had learned to become a taxidermist to supplement the family income.

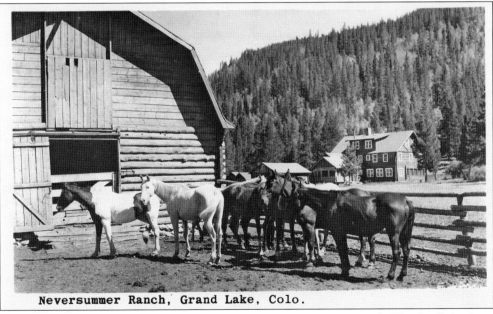

By the 1950s, the name of the resort was changed to Neversummer Ranch. The family business ended in 1974 when the ranch inholdings were sold to the National Park Service. The remainder of the property west and south of the Colorado River was acquired by the Nature Conservancy and was later purchased by the government after the park boundaries were expanded. The property is preserved today as a historic site.

Green Mountain Ranch began as a working ranch in the 1880s. It was located five miles north of Grand Lake in the Kawuneeche Valley. In the 1930s, owners Carl and Ada Nelson began entertaining guests at the ranch. This postcard from the *Steamboat Pilot* shows the start of a trail ride. The park service acquired the land in the early 1970s and retained several of the cabins for housing.

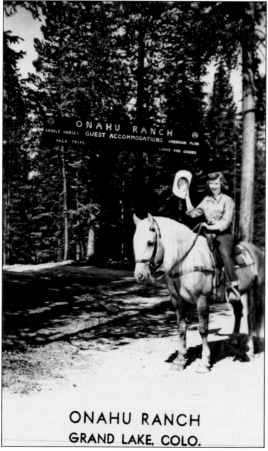

Onahu Ranch was located immediately to the south of Green Mountain Ranch near Onahu Creek. The property alternated between a working ranch and a dude ranch under various owners. This postcard shows the entry sign for the ranch, which lists saddle horses and pack trips as the main attractions. The National Park Service acquired the property in the 1960s and repurposed several of the buildings for seasonal housing.

Three

FALL RIVER ROAD AND TRAIL RIDGE ROAD

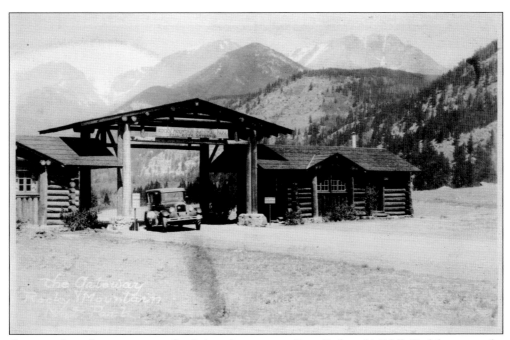

Construction of a government-funded road to connect Estes Park and Middle Park began on the east side in 1913 following a lobbying campaign by the Estes Park Protective and Improvement Association and other regional groups. Construction began on the west side in 1917 after Rocky Mountain National Park had been established. This postcard shows the original Fall River Entrance Station at Horseshoe Park. The road was completed in 1920. (Courtesy Bobbie Heisterkamp Collection.)

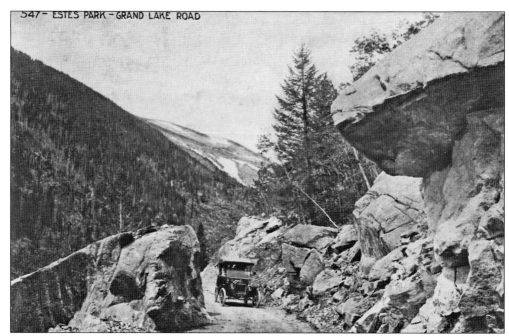

Fall River Road was built in sections; convict labor was initially used on the east side, while a crew managed by Dick McQueary worked from the west side. This HTT postcard was issued before the road's completion and shows the engineering challenges that were met in building a road through the rocky terrain. Some sections were only eight to 10 feet wide.

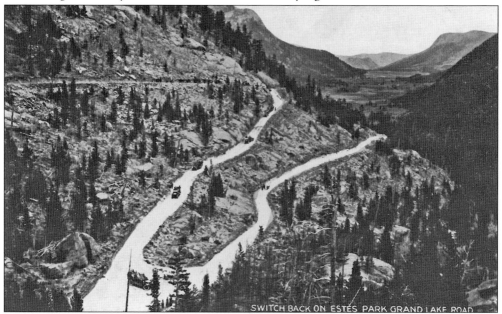

SWITCH BACK ON ESTES PARK GRAND LAKE ROAD

This W.T. Parke postcard shows a caravan of sightseeing buses from the Rocky Mountain Parks Transportation Company on Fall River Road after owner Roe Emery had been awarded a franchise for exclusive motor tour operations in the park. To avoid further delays, Emery's company helped fund completion of the road. It was engineered with a series of switchbacks containing grades of up to 16 percent.

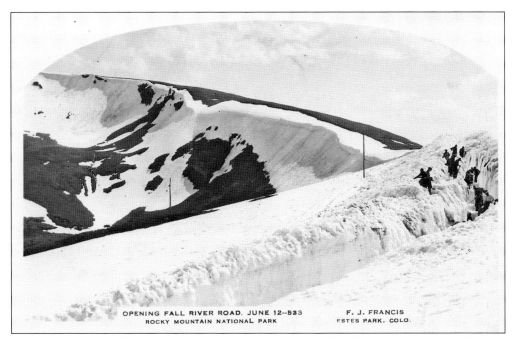

OPENING FALL RIVER ROAD. JUNE 12--533
ROCKY MOUNTAIN NATIONAL PARK

F. J. FRANCIS
ESTES PARK. COLO.

Guided tours over Fall River Road ran seasonally from the middle of June to October 1. Following a long winter, snow shovel gangs arrived at the first hint of spring to begin the monumental efforts to dig out a lane of travel with the help of a steam shovel. This F.J. Francis postcard was mailed in 1928 and shows more than a dozen men dwarfed by the huge snowbank.

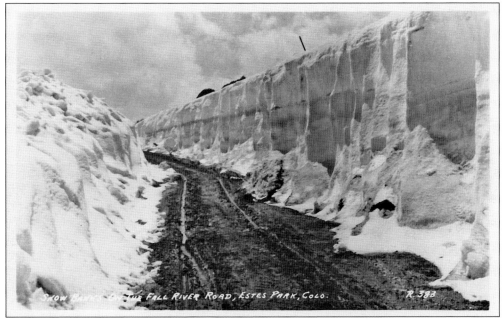

Muddy tire tracks can be seen in this postcard showing the steady path of a vehicle. Not all travelers were that fortunate. A team of horses was often deployed to rescue vehicles that became stuck on the route. The snowbanks were an imposing sight and could extend as high as 25 feet. Crews spent a month or more each year preparing the road for its season opening.

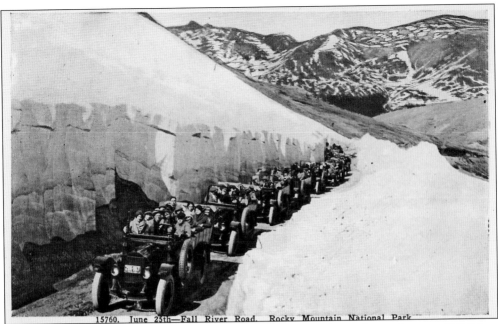

15760. June 25th—Fall River Road. Rocky Mountain National Park

Warmly dressed sightseers are shown in this HHT postcard as they enjoy a trip across Fall River Road in June. The open-air buses were provided by the Rocky Mountain Parks Transportation Company. After acquiring F.O. Stanley's transportation company in 1916, owner Roe Emery opted to use vehicles made by the White Motor Company in lieu of the Stanley Steamers. Emery's business expanded in later years and became the Rocky Mountain Motor Company.

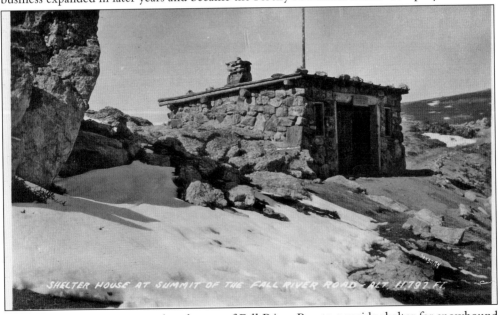

SHELTER HOUSE AT SUMMIT OF THE FALL RIVER ROAD ALT. 11797 FT.

This structure was constructed at the top of Fall River Pass to provide shelter for snowbound travelers until relief could be sent. Made of stone, the shelter house was built in the early 1920s and was equipped with a fireplace and firewood to provide protection against sudden storms. While no longer in use, the structure remains standing. Today, Fall River Road is open to one-way summer traffic as conditions permit.

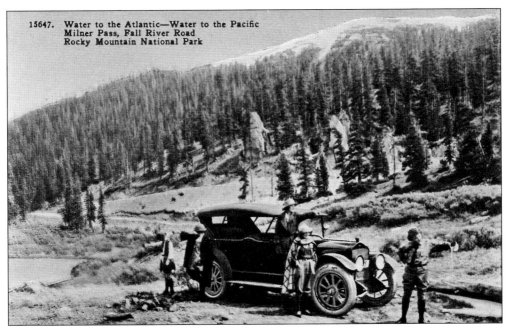

15647. Water to the Atlantic—Water to the Pacific
Milner Pass, Fall River Road
Rocky Mountain National Park

Fall River Road was promoted as the highest continuous skyline drive in the United States. This HHT postcard describes the significance of Milner Pass on the route. At an elevation of 10,759 feet, the Continental Divide is located here. Passengers point in opposite directions to illustrate how the water poured from their tin cups travels to the Atlantic on one side and to the Pacific on the other.

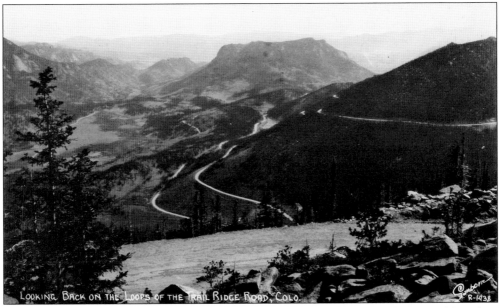

Not long after the opening of Fall River Road, the National Park Service began making plans for a more reliable route through Rocky Mountain National Park. A primitive Native American trail was used to help mark the new road, in which grades would be half as steep. Construction began in 1929, and the new Trail Ridge Road, with its sweeping loops, opened in 1932, replacing the earlier route.

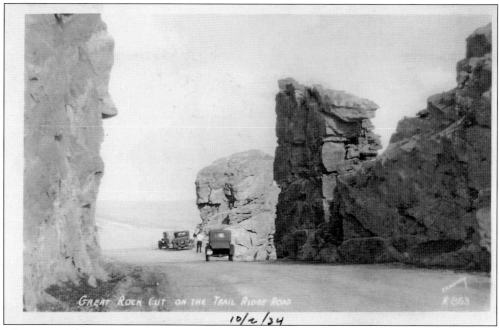

This postcard bears a handwritten date from 1934 and shows the Great Rock Cut on Trail Ridge Road at an elevation of more than 12,000 feet. Large amounts of dynamite were used to blast through the massive rock during construction of the road. So as not to mar the surrounding landscape, the remaining rocks were covered with timbers to protect them from the blasts.

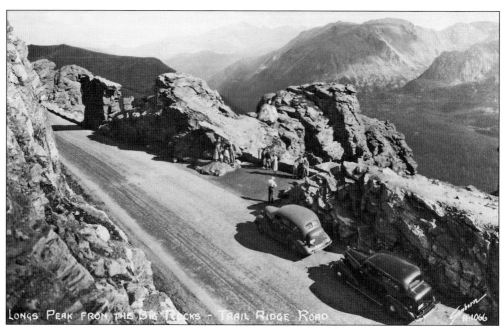

In a similar scene, travelers use the Big Rocks pull-off on Trail Ridge Road to take in the view of Longs Peak, the highest mountain in the park with an elevation of 14,259 feet. Admission to Rocky Mountain National Park was free until 1939, when a $1 fee was established.

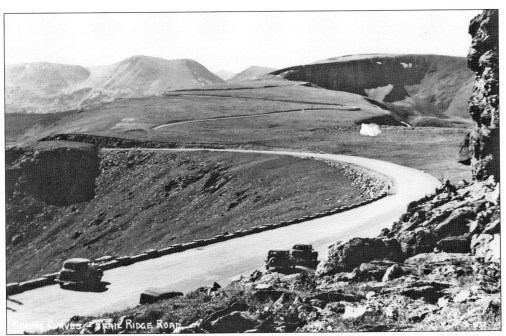

As the highest continuous paved road in the United States, the route includes 11 miles at an elevation of 11,000 feet or higher and four miles above 12,000 feet. This postcard of the tundra curves, mailed in 1946, shows the continuous loops built into the hillside that are used to gain elevation on the last rise to the top. The rock walls were constructed by the Civilian Conservation Corps.

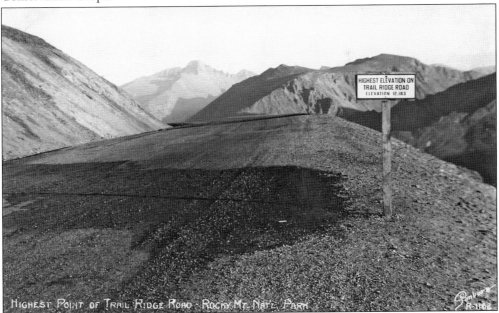

This postcard shows the road sign marking the highest point on Trail Ridge Road at an elevation of 12,183 feet on the 48-mile route between Estes Park and Grand Lake. The road was 24 feet wide and was built at an estimated cost of $450,000, with more than 150 construction workers on the job during its peak. Later postcards reflect a more precise elevation of 12,110 feet.

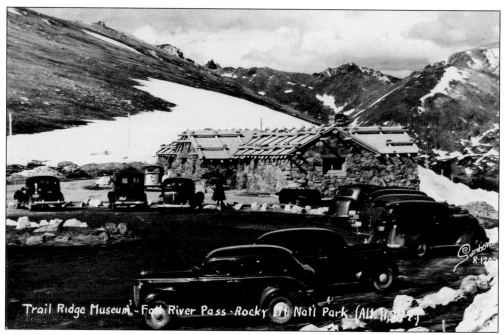

Trail Ridge Museum - Fall River Pass - Rocky Mt Natl Park. (Alt 11,797)

The Trail Ridge Museum and Post Office was built with permission from the National Park Service for use as a tourist stop by Roe Emery and his growing transportation company. It opened in 1937 and was constructed at the top of Fall River Pass at an elevation of 11,794 feet. Beam supports were attached to the roof to protect it from the heavy winds.

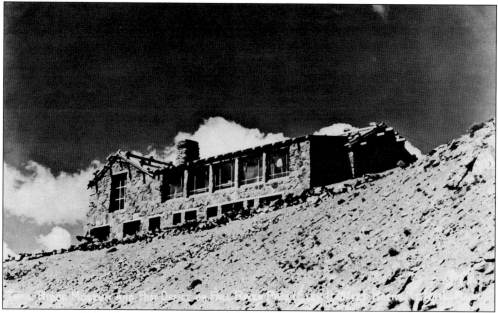

This postcard shows the back of the Trail Ridge Museum and Post Office and the large picture windows built to take in the mountain views. A variety of Native American souvenirs and other items were sold. The store also issued postmarks representing the highest post office in the United States. The store remains in operation today and shares a parking lot with the Alpine Visitor Center, which opened in 1965.

Four

Surviving Lodges, Ranches, and Other Historic Places

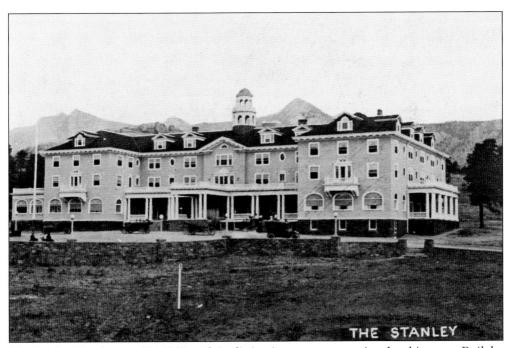

The Stanley Hotel opened in 1909 with its distinctive yet unconventional architecture. Built by newcomer Freelan Oscar Stanley in the Georgian Colonial Revival style he had known from New England, the hotel introduced a new era of sophistication for Estes Park. This c. 1910 W.T. Parke postcard shows the hotel with several Stanley Steamers in front. The vehicles served as a critical transportation link for the hotel's railroad-traveling guests.

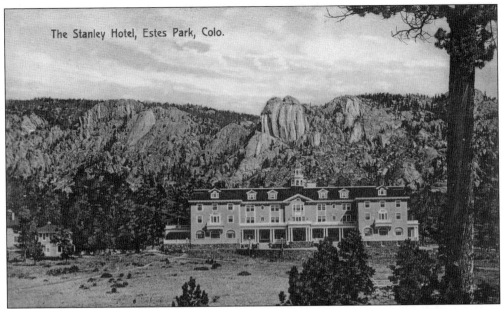

The Stanley Hotel, Estes Park, Colo.

No expense was spared in constructing the hotel, which was positioned along a knoll with majestic mountain views. Suffering from tuberculosis, the 53-year-old Stanley traveled to Estes Park from the East Coast to experience the healing powers of Colorado's dry climate. Accompanied by fortunes from a previous invention, Stanley invested heavily in his new surroundings, as shown on this W.T. Parke card. (Courtesy Bobbie Heisterkamp Collection.)

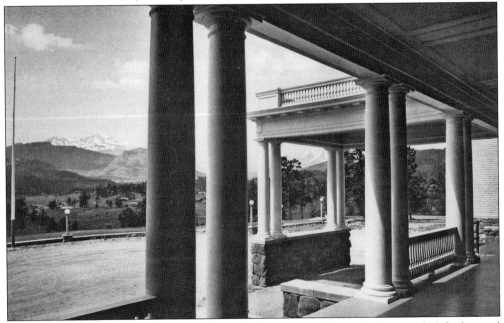

The contributions of F.O. Stanley to the transformation of Estes Park extended far beyond his hotel and transportation operations. Stanley's innovations and investments also supplied electricity, water, sewage, and improved roads for the area. This W.T. Parke postcard shows the view of Longs Peak from the porch of Stanley's hotel, in which guests experience the building's placement and its natural surroundings just as Stanley had envisioned.

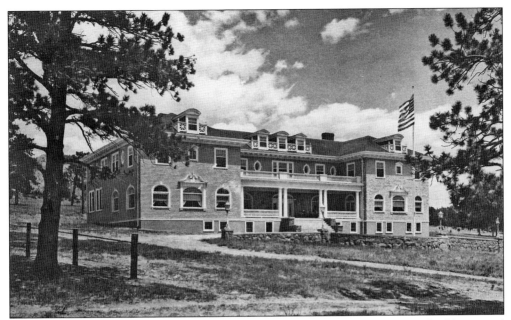

So successful was the original Stanley Hotel that arrangements were made to build a second hotel. The smaller Stanley Manor, pictured on this W.T. Parke postcard, was completed in 1910 and was located to the east. It included 33 rooms, a dining room, a parlor, and a billiard room. In all, there were 11 buildings on the 160-acre grounds, including Stanley Hall, which was built for concerts and dances.

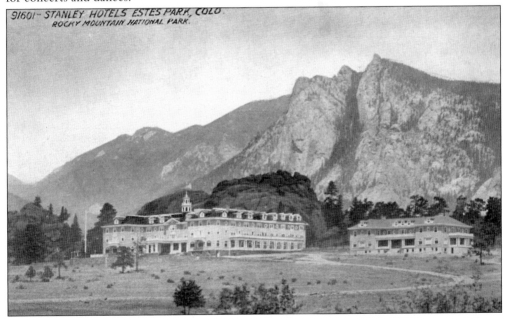

Accommodations at the Stanley hotels were opulent in every way. This HHT postcard shows the positioning of the Stanley Hotel (left) and the Stanley Manor (right). Here, according to the card's description, "the visitor can enjoy all the comforts and luxuries of metropolitan life while viewing the Rocky Mountains in their winter aspect." Both properties were operated year-round, with the exception of the midwinter months and together housed 300 guests.

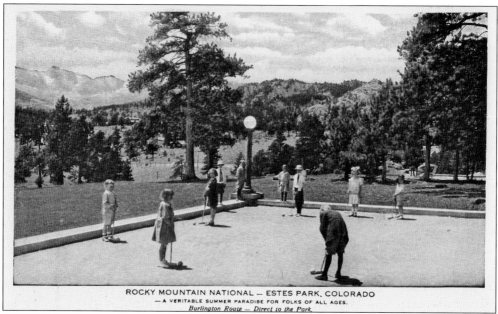

ROCKY MOUNTAIN NATIONAL — ESTES PARK, COLORADO
— A VERITABLE SUMMER PARADISE FOR FOLKS OF ALL AGES.
Burlington Route — Direct to the Park

Postcards were produced by the Burlington Route to promote Estes Park and Rocky Mountain National Park as a notable summer railroad excursion. Images from the Stanley grounds were used to showcase activities to entice the interests of affluent travelers—including this card, which shows children enjoying a game of croquet. A guest could leave Chicago at 10:30 a.m. and arrive in Estes Park the next afternoon.

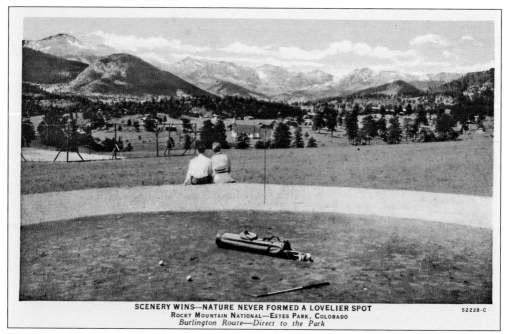

SCENERY WINS—NATURE NEVER FORMED A LOVELIER SPOT
ROCKY MOUNTAIN NATIONAL—ESTES PARK, COLORADO
Burlington Route—Direct to the Park
52228-C

Another Burlington Route card captures the surrounding beauty of the Stanley golf course, located in full view of the hotel verandas. A tennis court was located nearby, and a swimming pool was added in later years. These activities were complemented by a well-equipped livery stable that was maintained off-site. The Burlington Route advertised direct service to the park.

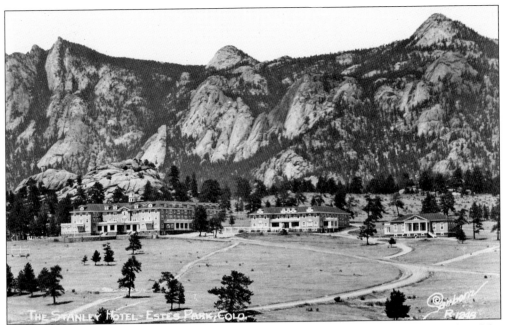

This postcard shows the Casino Building, also called Stanley Hall, located to the right of the hotels. Operations remained in F.O. Stanley's ownership until 1929, when he sold the property to his former transportation rival, Roe Emery of the Rocky Mountain Motor Company. Emery continued operations until about 1946. The next owner of the Stanley Hotel property was Abbell Management Company.

The Abbell Management Company transformed the Stanley Hotel's image to a family-friendly Western theme, as illustrated by this postcard, to help lure vacationers back from the rationing days of World War II. During the ensuing years, the hotel fell into disrepair. Today, its successful year-round operation by owner John Cullen stands as a fitting tribute to the legacy of F.O. Stanley.

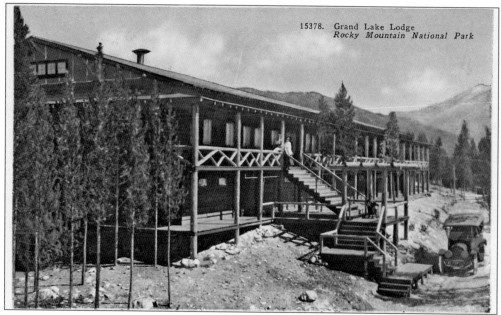

Grand Lake Lodge was built to complete a plan to provide guided bus tours through Rocky Mountain National Park with overnight stops in Estes Park and Grand Lake. This HHT postcard shows the lodge as it looked after its opening in 1920. It was constructed within the park's boundaries and was arranged by transportation pioneer Roe Emery, who had successfully negotiated a government franchise for tour operations within the park.

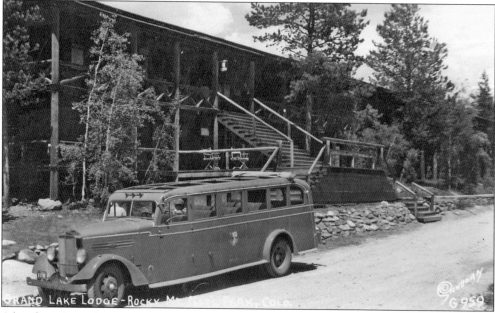

A bus from Emery's Rocky Mountain Motor Company is prominently featured on this postcard from later years. Guests taking part in the 240-mile Circle Tour arrived at Grand Lake Lodge after completing a scenic drive through the park, first along Fall River Road and transitioning to the modern route over Trail Ridge Road in the 1930s. The multiday tours were launched in 1921 and began and ended in Denver.

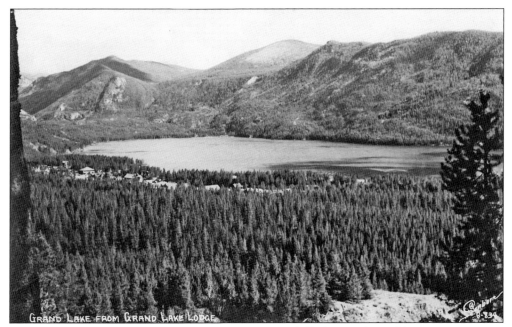

The building site for Grand Lake Lodge was on a piney hillside near the park's western entrance, which provided panoramic views of Grand Lake, the village, and the surrounding mountains. Construction was arranged by A.D. Lewis, an acquaintance of Roe Emery. Lewis was a banker and hotelier from Estes Park with enterprises that included operation of the Lewiston Chalets and the Lewiston Hotel.

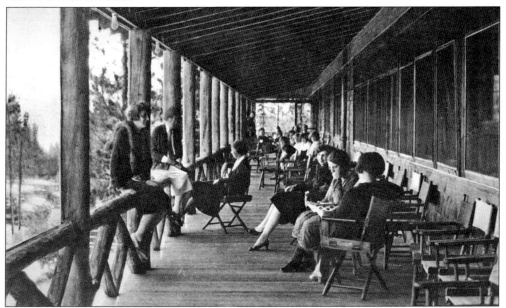

One of the most inviting features of Grand Lake Lodge is its covered veranda, which spans the full length of the building. The porch was lined with an assortment of chairs and swings where guests gathered to enjoy the view. This Clatworthy postcard, mailed by a guest in 1929, describes an upcoming program on birds and wildlife that was taking place at the lodge later in the evening.

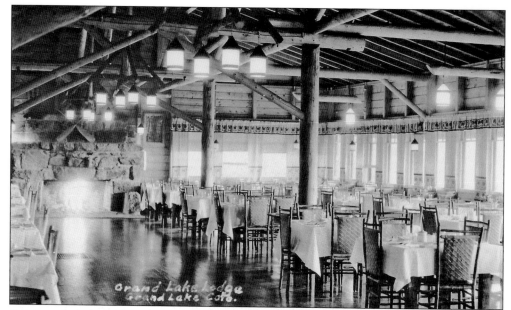

Guests took their meals in the main lodge building. The dining hall featured hand-peeled beams and columns made of lodgepole pine. Dinner service took up one end of the 150-foot-long building, while a lobby occupied the other side. This postcard shows the Grand Lake Lodge dining room furnished in the familiar rustic hickory style found at other national parks. Sunlit windows and a fireplace provided additional charm.

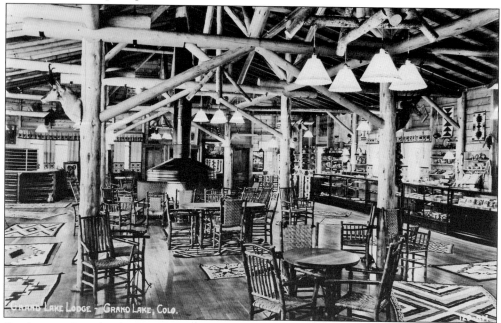

On the opposite side of the dining hall, a large circular fireplace graced the lobby area to replicate a campfire. This is where guests gathered to hear evening nature talks. Navajo rugs added warmth to the hardwood floors, while the walls were decorated with Native American weavings as well as various taxidermy mounts. Souvenirs could be purchased from the gift shop pictured on the right. A fire nearly destroyed the lodge in 1973.

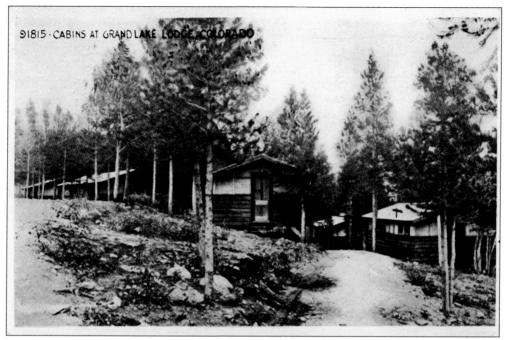

Guests stayed in one- and two-room cabins located behind the lodge as shown on this HHT postcard. In all, there were more than 100 buildings on the grounds, which included the cabins, a horse stable, and a dormitory that housed a recreation hall. The property had its own water supply and a hydro plant that generated electricity.

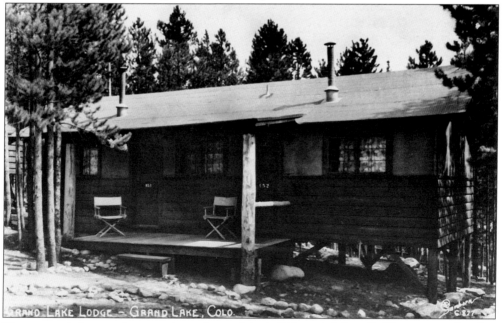

The postcard shows a close-up view of one of the buildings and the stilt-like construction that was used to compensate for the rocky and uneven terrain. Each of the cabins had electric lights, running water, and a stove. Some had private baths. The lodge operated seasonally from June 15 to October 1 and could eventually accommodate up to 300 guests.

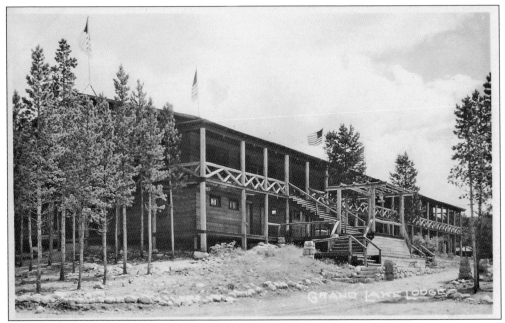

In 1923, with his transportation company showing success, Roe Emery entered the lodging business with the acquisition of Grand Lake Lodge and the Lewiston Chalets, located in Estes Park. Purchased from A.D. Lewis around the time this postcard was produced, the lodging was a way for Emery to begin to control all aspects of his Circle Tour package. He continued to own Grand Lake Lodge until about 1953. The lodge is still operating today.

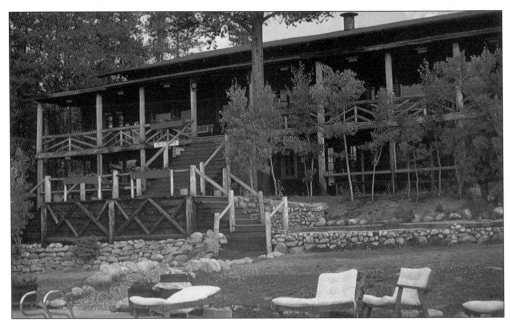

In the mid-1950s, brothers Isaac B. and Ted L. James acquired the Grand Lake Lodge property along with other lodging and transportation holdings. The family saved the lodge from possible government acquisition when they negotiated a land exchange to remove the property from the park's boundaries in 1963. This postcard is by the Flatiron Postcard Company.

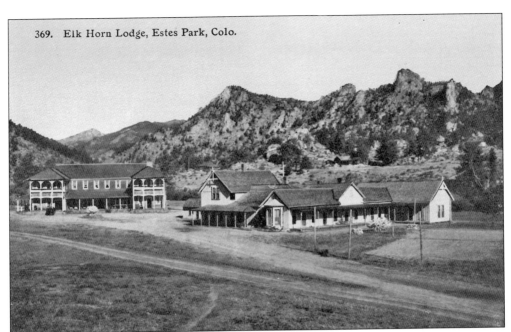

369. Elk Horn Lodge, Estes Park, Colo.

William and Ella James settled in the valley just west of Estes Park in 1876 to run a cattle ranch. When travelers came looking for room and board, a hotel was born. Early accommodations at Elkhorn Lodge included tent houses and the ranch house pictured on the right. This Barkalow Bros. postcard also shows the new lodge building that was constructed in 1901.

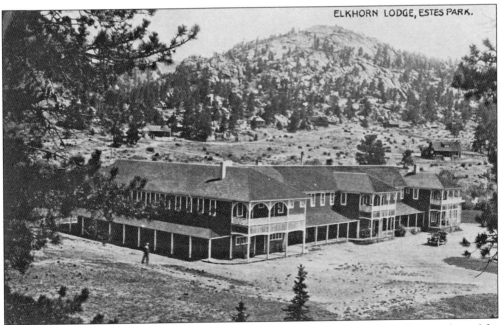

ELKHORN LODGE, ESTES PARK.

This W.T. Parke postcard shows the main Elkhorn Lodge building after it had been enlarged for a second time in 1911. There were once more than 30 buildings on the grounds to accommodate 250 guests. The lodge remained a family-run operation until it was sold in 1961. Many of the original buildings are still standing.

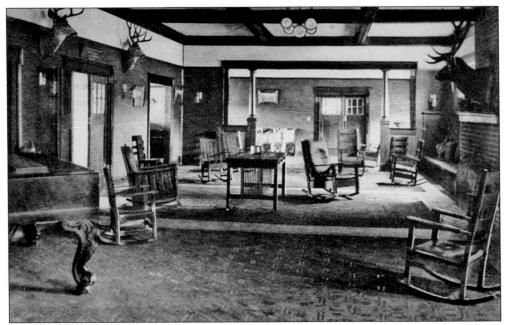

This c. 1910 Albertype Company postcard shows the living room of Elkhorn Lodge, promoted as a hotel of high standards. The room includes a piano for entertaining and rocking chairs in the Arts and Crafts style. Decorative mounts of deer and elk hang from the walls and above the fireplace. For years, the lodge was known for its huge pile of antlers stacked out front. (Courtesy Bobbie Heisterkamp Collection.)

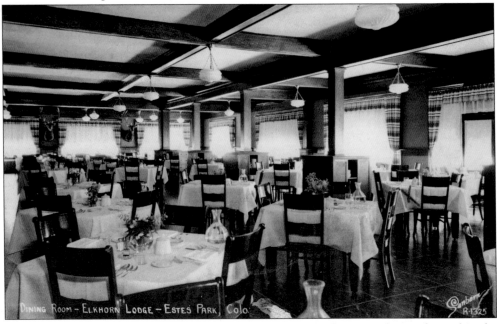

The dining room at Elkhorn Lodge, with a seating capacity of 150 people, was located in the main lodge building, situated at the base of Old Man Mountain. An early brochure from the property describes the cuisine as first-class with an experienced chef in charge. Milk and cream were supplied from the lodge's own dairy. (Courtesy Bobbie Heisterkamp Collection.)

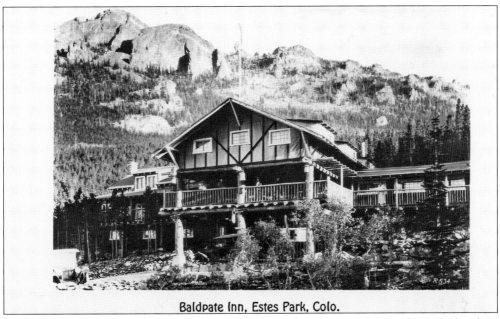

Baldpate Inn, Estes Park, Colo.

The Baldpate Inn, located seven miles south of Estes Park, was opened around 1917 by brothers Gordon and Charles Mace and other family members on newly homesteaded land. At the time, the inn was one of the few lodges with electricity and indoor plumbing. Soon after its opening, additions were made to the east and west sides. Arriving guests entered through the porte cochere beneath the observation deck.

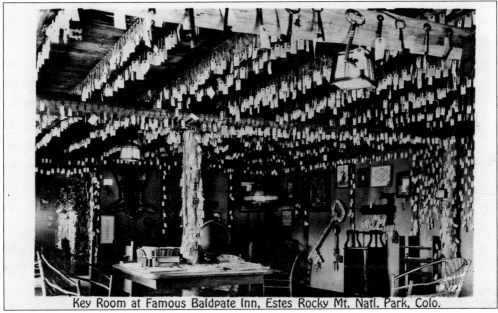

Key Room at Famous Baldpate Inn, Estes Rocky Mt. Natl. Park, Colo.

Naming their inn for the mystery novel *Seven Keys to Baldpate*, the Maces used clever marketing schemes to attract interest. For a time, guests received souvenir keys during check out until the practice became cost-prohibitive. In 1922, the Maces began inviting guests to send their own keys. The collection grew so large that in 1935 a key room was created to display the thousands of donated keys from around the world.

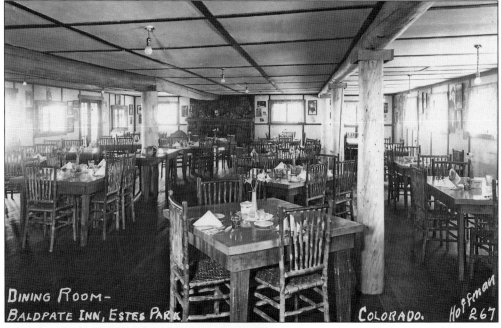

Dining Room— Baldpate Inn, Estes Park. Colorado. Hoffman 267

A wing was added to the Baldpate Inn's east side to house the dining room, where chicken, steak, and trout dinners were served. This 1940s Hoffman card shows the room furnished with rustic-style tables and chairs. A stone fireplace is visible in the back of the room. Other additions to the property included a west-side wing, a dance hall, several cabins, a stable, and a garage.

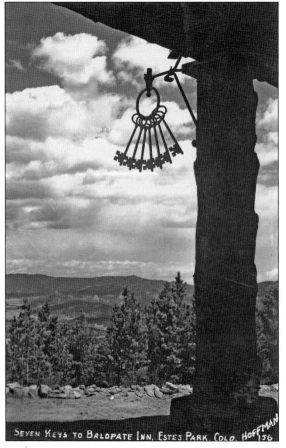

Seven Keys to Baldpate Inn, Estes Park, Colo. Hoffman 156

This Hoffman postcard shows the seven keys that hung from the porch. The sender of the card writes, "This is the most wonderful place in the park. It faces a mountain that has a big bald pate [Lily Mountain]. I'd love to spend a month here." The property is listed in the National Register of Historic Places as a surviving example of an early tourist attraction.

The Lewiston Chalets, built around 1919 by A.D. Lewis, replaced an earlier lodge on the site overlooking Marys Lake at the eastern entrance to Rocky Mountain National Park. The lodge served as a luncheon stop for Roe Emery's Circle Tour, which used a fleet of touring vehicles made by the White Motor Company to transport sightseers. This Clatworthy postcard shows tour guests and staff members posing for a group photograph.

In 1923, A.D. Lewis sold the Lewiston Chalets to Roe Emery, who changed the name of the lodge to the Estes Park Chalets. Expansions ensued, and by 1935, the property could accommodate 300 guests. In the 1950s, the lodge was sold to the James family, which acquired other Emery enterprises, including the tour bus operation and Grand Lake Lodge. The property is now operated as Marys Lake Lodge. It was rebuilt after a catastrophic fire in 1978.

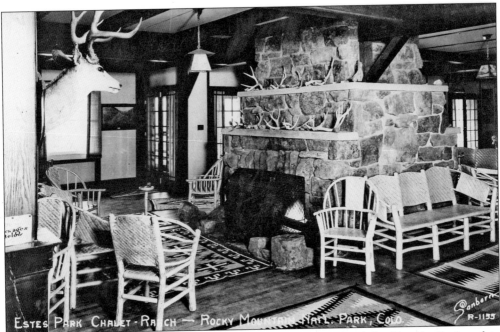

By the 1940s, the property had expanded its name to Estes Park Chalet-Ranch. Designed to provide comfort and informality, the lobby featured a large stone fireplace with antlers placed on the mantle opposite a mounted trophy deer. Saddle horses were kept on the property and outdoor steak fries were offered as part of the Western experience where up to 100 steaks could be broiled simultaneously on a giant stone fireplace.

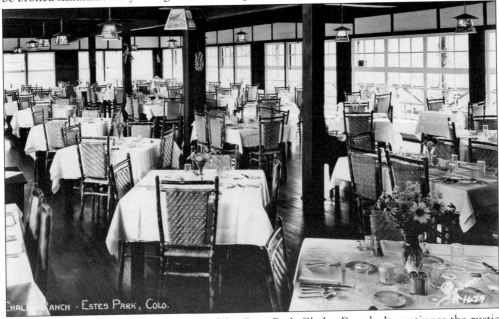

This postcard shows the dining room of the Estes Park Chalet-Ranch. It continues the rustic theme with sturdy hickory chairs and lighting in the Arts and Crafts style. The room could seat 200 guests and was glass-enclosed on the east and north to provide views of Marys Lake, Prospect Mountain, and the Mummy Range.

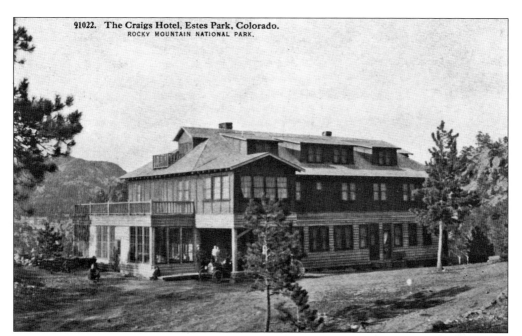

The Crags Hotel, shown in this HHT postcard, opened in 1914. It was named for the way it was constructed into the craggy part of the north side of Prospect Mountain above Estes Park. The hotel was built and operated by Enoch "Joe" Mills, the brother of naturalist Enos Mills. Upon Enoch's death in 1935, his wife, Ethel, continued operations until the mid-1940s when it was sold to another family.

This 1930s postcard shows the hotel after new guest rooms had been added along with a recreation hall. The sender of the card was preparing to climb Prospect Mountain later that morning at an elevation of 8,896 feet. "It's cool and scenery is grand," she writes. "I'm so glad I'm making my stay at this hotel." The Historic Crags Lodge is operated today as a full-service resort.

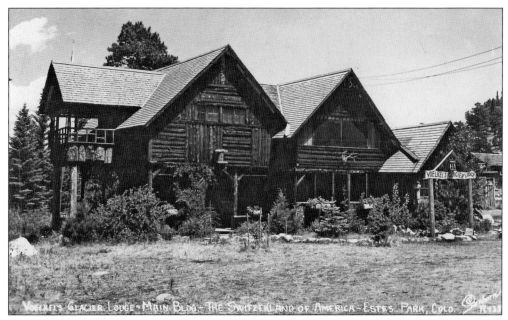

A homestead cabin along the banks of the Big Thompson River, built in the 1900s, was the impetus for Voelkel's Glacier Lodge, operated by Grover and Cora Voelkel, beginning around 1935. Cora was the daughter of Colorado governor James Hamilton Peabody, who served from 1903 to 1905. The main lodge building, with its distinctive rustic architecture, is shown in this postcard proclaiming the area as "the Switzerland of America."

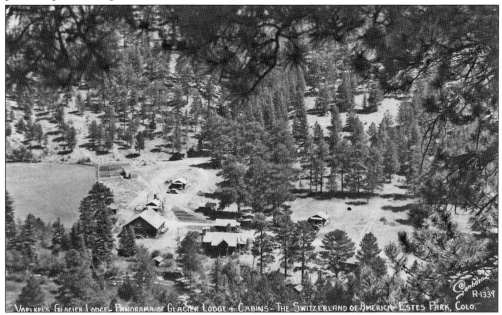

This postcard shows a panorama of Voelkel's Glacier Lodge, which includes the homestead lodge, dining room, cabins, and saddle livery. Family housekeeping cabins were added in later decades. A popular activity was the Thursday-night steak fry, which combined a trail ride with dinner served around a campfire with Western-themed entertainment. Now known as Glacier Lodge, the 20-acre guest ranch is located three miles southwest of Estes Park.

Located at the east entrance to the Big Thompson Canyon in the Olympus Heights neighborhood, Camp Olympus was built in the early 1920s to be used as a base camp for summer sessions by the Colorado State Teachers College in Greeley, now the University of Northern Colorado. This postcard shows the original three-story lodge and six hillside cabins with the Big Thompson River in the foreground.

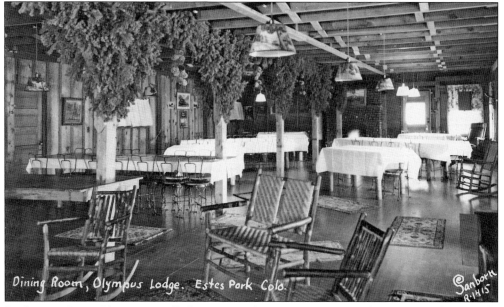

Students at Camp Olympus enrolled in two–week extension courses. The camp was also used for weekend excursions by students and faculty members. Lodging was available for $1 per night, and meals were 50¢. This postcard shows the dining room, which was furnished with metal parlor chairs and rustic history furniture. Classes were discontinued in the mid-1930s, and the property was converted to guest lodging, which continues today.

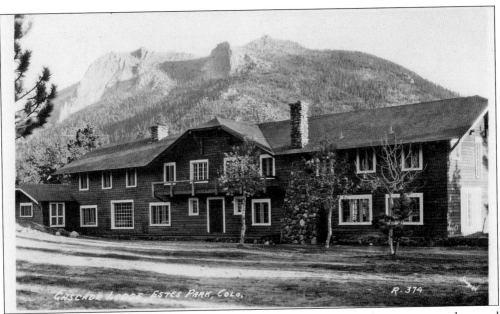

The Cascade Lodge, located near the park's Fall River Entrance Station, was opened around 1925 and included this lodge building and several cottages. Summer classes were once offered here by Denver University. After fire destroyed the main lodge building in 1935, the property continued operations with its inventory of summer cottages. It is the last remaining privately owned lodging facility in the park.

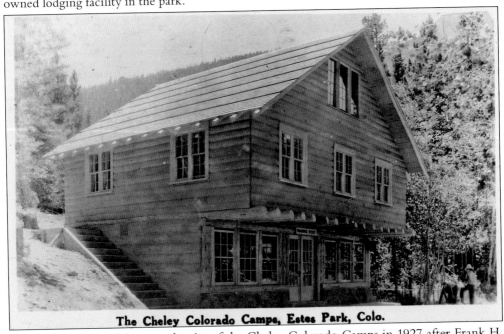

Land O'Peaks Ranch became the site of the Cheley Colorado Camps in 1927 after Frank H. Cheley consolidated his boys' and girls' camps that were being operated in separate locations. The ranch is located in an elevated valley overlooking Estes Park from the south. This postcard shows the Trading Post building, which supplied various sundries to the campers. The camp is operated today by third- and fourth-generation family members.

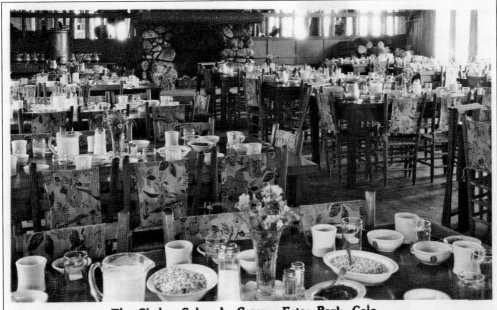

The Cheley Colorado Camps, Estes Park, Colo.

This postcard shows the interior of the Ski Hi Lodge dining hall at Cheley Camp. The meals were prepared by experienced professional cooks and served family style in custom chinaware stamped with the familiar horse and rider mark. One of the more interesting features in the dining hall is a natural sculpture that can be found on top of the stone fireplace.

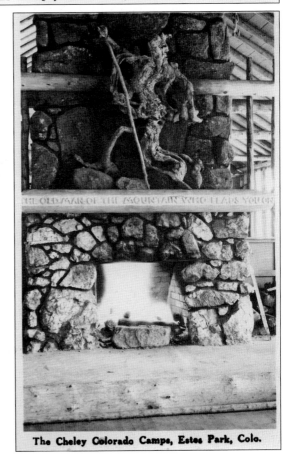

The Cheley Colorado Camps, Estes Park, Colo.

The dining hall fireplace sculpture is made from a stump salvaged by camp employee Grant Wood, who gave the newfound art a home and carved an accompanying inscription on the log mantle referencing the "Old Man of the Mountain." The camp was filled with mottos inscribed on walls, doors, and elsewhere to provide inspiration. Wood, an artist from Iowa, later gained fame for his *American Gothic* painting, created in 1930.

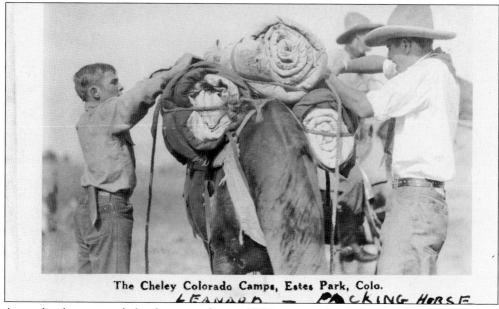

The Cheley Colorado Camps, Estes Park, Colo.
LEANARD — PACKING HORSE

A noted author on youth development after establishing camps for the YMCA, Frank Cheley was passionate about the opportunity to provide young people with firsthand wilderness experiences to shape their character. Affluent families were recruited from across the country to send their children to the renowned camp. Promotional materials were filled with testimonials and endorsements from proud parents.

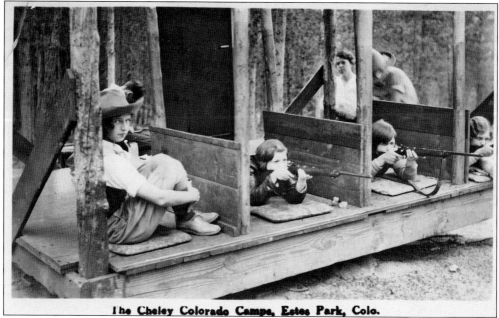

The Cheley Colorado Camps, Estes Park, Colo.

The Cheley Camp experience included individualized instruction in horsemanship, campcraft, woodcraft, mountaineering, natural science, and most of all, learning to become "self-propelled, independent individuals with real character and personality," according to promotional materials. Published rates for 1934 ranged from $35 to $45 per week per camper, or $300 to $400 for the full 10-week season. In this postcard, girls hone their marksmanship skills at the rifle range.

74

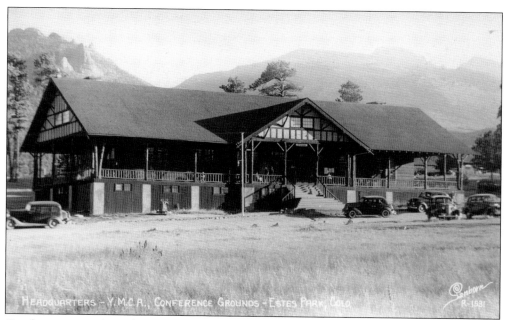

Conference organizers from the Young Men's Christian Association arrived in Estes Park in 1907 to begin planning a summer training center. After hosting a conference in 1908, the group purchased the Wind River Lodge southwest of town, which formed the beginning of the 860-acre YMCA of the Rockies compound. The administration building, shown here, opened in 1910 and has remained a focal point of activity. (Courtesy Bobbie Heisterkamp Collection.)

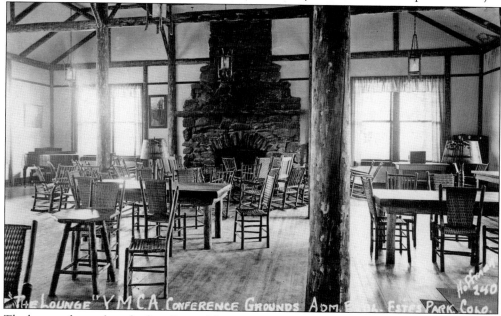

The lounge, located on the first floor of the YMCA Administration Building, is featured on this Hoffman postcard. The room includes a large stone fireplace against the back wall and wooden beams and columns. Tables, chairs, and rockers made in the rustic history style fill the room, while light fixtures in the Arts and Crafts motif hang from the ceiling. A piano is also visible. (Courtesy Bobbie Heisterkamp Collection.)

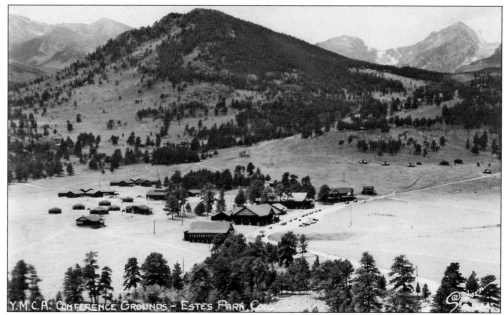

This postcard shows the YMCA property after additional buildings had been added. The Hyde Memorial Chapel, built in 1913, is located left of the administration building. The smaller structure to the right of the main building is the post office, followed by the dining hall. The Wind River Lodge is situated to the right of the dining hall. Cabins, as well as larger lodging facilities, are scattered throughout the grounds.

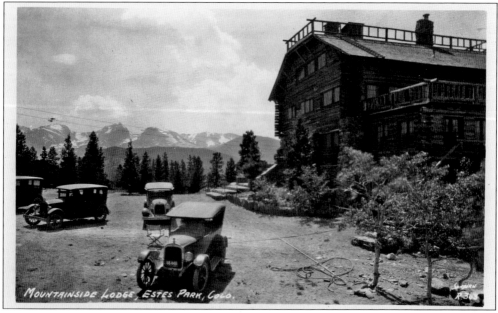

Located high above the western boundary of the YMCA grounds, Mountainside Lodge was built around 1920 for use as a summer home for Chicago minister Dr. John Timothy Stone. After the house was sold in 1924, it had various owners and uses until 1956, when it was purchased by the YMCA. The lodge has since been renovated and is available for weddings, retreats, and other gatherings. (Courtesy Bobbie Heisterkamp Collection.)

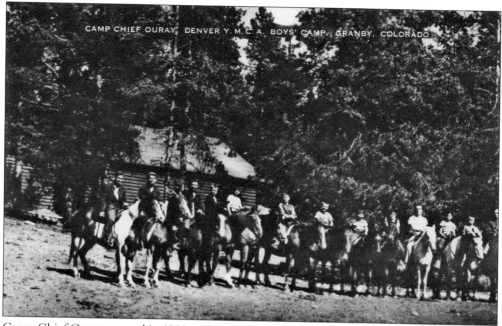

Camp Chief Ouray opened in 1908 and was located along the Colorado River north of Granby in Middle Park. It was operated by the Denver YMCA until 1979, when it was sold to the YMCA of the Rockies. This Artvue postcard was mailed in 1956 by a camper who writes, "It is nice and cool hear [sic]." In 1980, Camp Chief Ouray was relocated to Snow Mountain Ranch near Granby.

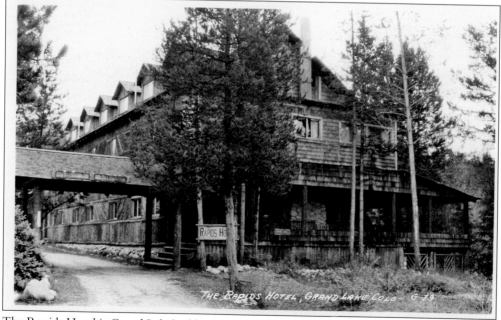

The Rapids Hotel is Grand Lake's oldest operating lodge. Situated along the North Inlet Creek a few blocks northeast of downtown, the hotel opened around 1915. It was constructed and operated by John Lapsley Ish, a former miner who built and ran a hotel in a neighboring county before returning to Grand County to build his new hotel.

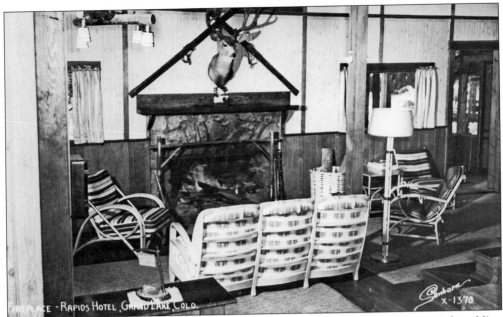

FIREPLACE - RAPIDS HOTEL, GRAND LAKE, COLO.

Ish continued to run the Rapids Hotel until the early 1940s. Its history includes stories of gambling and other illicit activity in the years after Ish retired. It was the first building in Grand Lake to have running water and electricity. In this 1950s postcard view, furnishings have been updated to reflect modern times. Now known as the Historic Rapids Lodge and Restaurant, its colorful past is celebrated by the current owners.

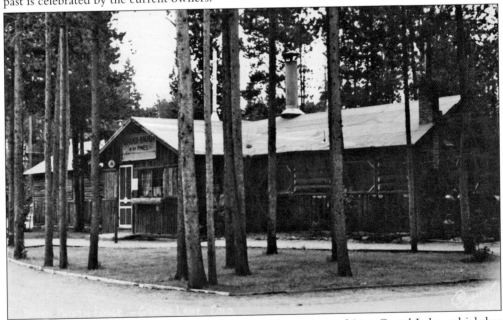

Daven Haven Lodge was built in the 1930s along the main road into Grand Lake, which has since been rerouted. It was owned and operated for more than 30 years by Lester and Cornelia Piper and her mother, Lela Davis. The lodge facilities include this headquarters building, part of the Daven Haven in the Pines compound. The property remains in operation today with lodging and restaurant service.

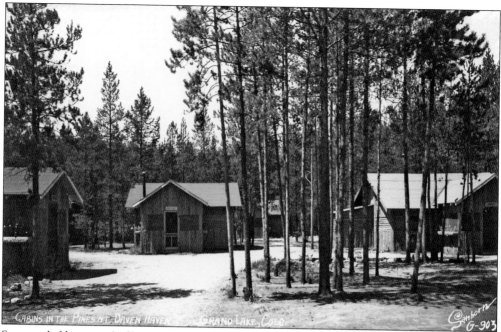

Surrounded by a stand of lodgepole pines, the Daven Haven grounds included a group of cottages, plus a playground, picnic area, and campfire spots. An outdoor swimming pool and additional cabins were added in later years. The original cabins varied in size and could accommodate from two to seven people. The largest was a three-bedroom family cottage with a living room and fireplace.

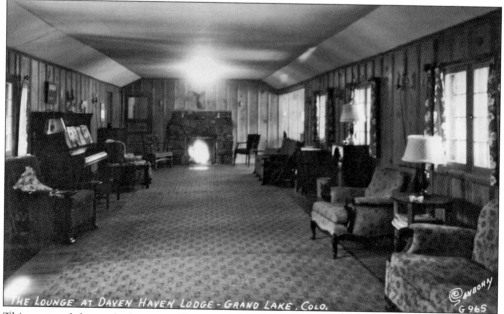

This postcard shows the lounge at Daven Haven in the Pines, where guests would gather around the fireplace to relax or enjoy some entertainment at the piano while waiting for dinner service. Long remembered for its cuisine, the resort was listed in the Duncan Hines books for years and was featured by *Better Homes and Gardens* in its series "Famous Foods from Famous Places."

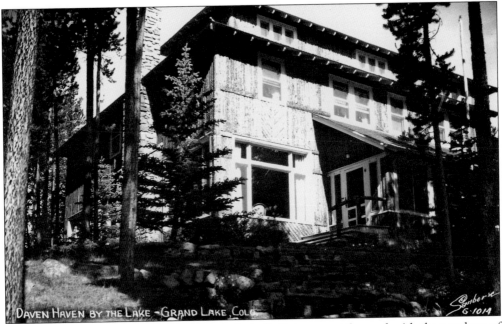

In the 1940s, the lodge was expanded to include facilities across the road with the purchase of an 11-bedroom lake house. Daven Haven on the Lake was promoted as the only lakeshore hotel with most rooms overlooking Grand Lake. The property included a private beach for sunbathing, swimming, boating, and water-skiing instruction. A trained counselor was on-site each day to arrange special programming for the children.

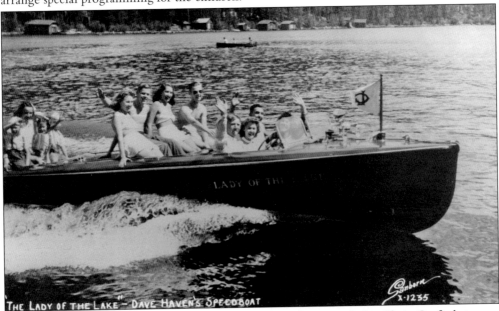

This postcard shows one of the classic mahogany speedboats made by Chris-Craft that were kept in select boathouses around the lake. This boat, *Lady of the Lake*, was owned by Daven Haven Lodge. It bears a Grand Lake Yacht Club flag on the front. The distinctive Chris-Craft boats have served as iconic symbols of Grand Lake's boating history for many years. (Courtesy Bobbie Heisterkamp Collection.)

Five

LONGS PEAK AND THE TAHOSA VALLEY

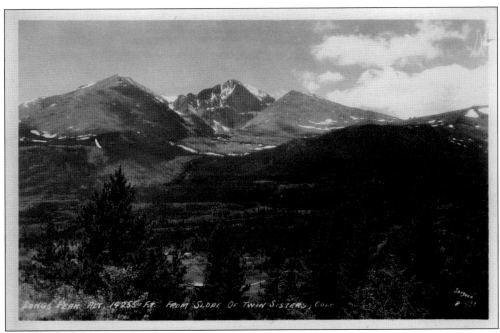

Longs Peak is the tallest mountain in Rocky Mountain National Park at an elevation of 14,259 feet. It is named for Maj. Stephen H. Long, who recorded the sighting during an expedition in 1820. The first recorded ascent took place in 1868 by a survey party led by Maj. John Wesley Powell, the one-armed Civil War veteran, and William Byers, publisher of the *Rocky Mountain News*.

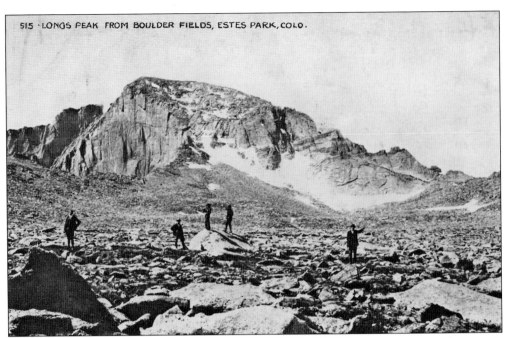

In 1878, hotelier Elkanah J. Lamb became the first regular guide to escort adventurers to the summit of Longs Peak using the East Longs Peak Trail. Lamb and son Carlyle spent years improving the trail after its use by earlier climbers such as Isabella Bird. The trail wound its way for six miles to the Boulder Field along the Keyhole Route, as pictured on this HHT postcard.

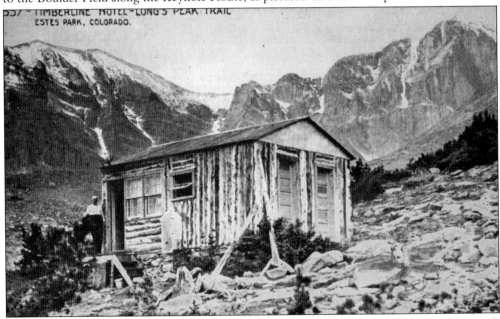

The Timberline Cabin was built around 1908 by Enos Mills, a distant relative of Elkanah Lamb, to assist in guided summits to Longs Peak. Located at an elevation of 11,000 feet, the tiny structure housed sleeping quarters on one end and a combination kitchen-dining area on the other. Guests on commercial-led climbs often spent the night before continuing their climb. By 1924, the cabin was closed due to its deteriorating condition.

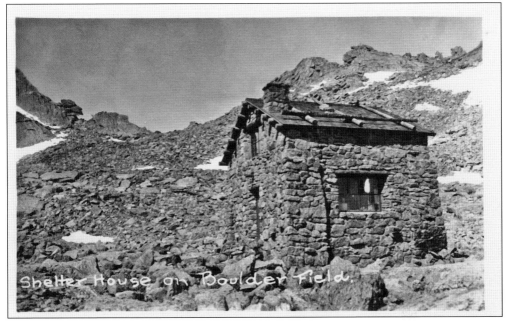

This F.J. Francis card shows the Boulderfield Shelter Cabin built in 1925. Its construction was prompted by the deaths of Agnes Vaille and a member of her rescue party, Herbert Sortland. It happened earlier that year when Vaille died while waiting for rescuers to reach her after sustaining injuries from a fall as she was descending the North Face. She had just completed the first winter ascent of the East Face. (Courtesy Bobbie Heisterkamp Collection.)

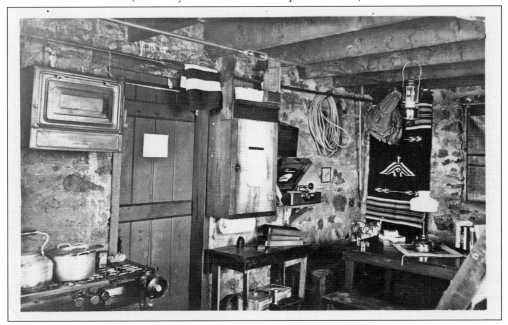

The interior of the Boulderfield Shelter is shown in this unmarked postcard. It was equipped with a stove, a small seating area, sleeping quarters, and other basic necessities. The building was used by climbers until the mid-1930s. It was dismantled about 1937 after structural problems were discovered caused by the shifting surface. (Courtesy Bobbie Heisterkamp Collection.)

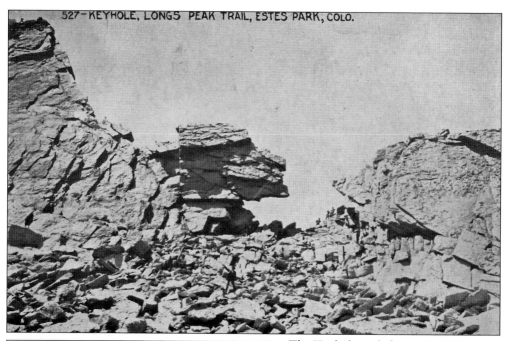

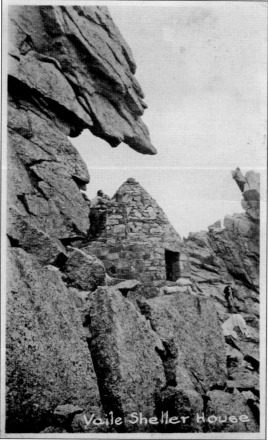

Vaile Shelter House

The Keyhole rock formation is located more than a mile from the summit of Longs Peak and has served as the turnaround point for hikers ill-equipped to continue. This HHT postcard shows the rugged break in the granite walls in a view looking south between Glacier Gorge and the Boulder Field. To reach the Keyhole, climbers scrambled over boulders of varying shapes and sizes.

The Agnes Vaille Shelter House, as pictured on this F.J. Francis postcard, is located at the Keyhole at an elevation well above 13,000 feet. It was completed in 1927 to honor Vaille and her rescuer, Herbert Sortland. It remains as a stark reminder of the harsh conditions of the mountain. The shelter house was added to the National Register of Historic Places in 1992. (Courtesy Bobbie Heisterkamp Collection.)

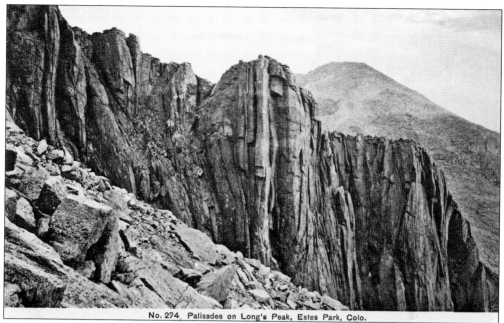

No. 274 Palisades on Long's Peak, Estes Park, Colo.

This W.T. Parke postcard shows the towering Palisade cliffs jutting out of the mountain below what climbers call the "Homestretch" on the way to the summit of Longs Peak, with Mount Meeker in the background. Throughout the decades, climbers have experienced unforgiving conditions on the mountain, with high winds, dangerous lightning, rain, hail, and snow.

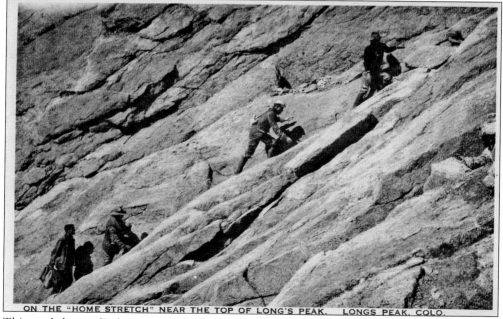

ON THE "HOME STRETCH" NEAR THE TOP OF LONG'S PEAK. LONGS PEAK, COLO.

This card shows climbers on the final pitch before reaching the summit of Longs Peak. The postcard was published by the widow of naturalist Enos Mills, who was determined to continue operations of the Longs Peak Inn and its climbing tours after the untimely death of her husband at age 52. One of the guides was Shep Husted, who reported as many as 50 climbs during the 1907 summer season.

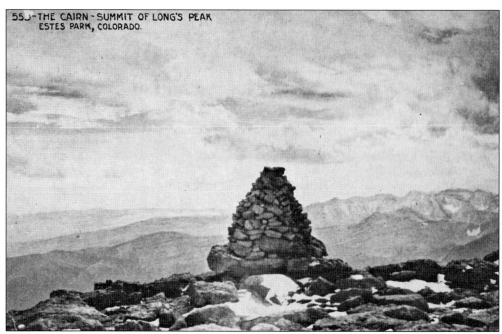

55J - THE CAIRN - SUMMIT OF LONG'S PEAK ESTES PARK, COLORADO.

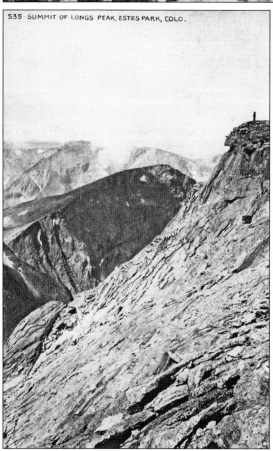

535 - SUMMIT OF LONGS PEAK, ESTES PARK, COLO.

This HHT postcard of "the Cairn" shows a stone-made landmark on top of the Keyhole Route's Homestretch on the approach to the summit of Longs Peak. The Colorado Mountain Club, founded in 1912, was instrumental in organizing group outings to the summit prior to establishment of Rocky Mountain National Park. The all-time Longs Peak summit record is held today by Jim Detterline of Estes Park, who in 2010 overtook Shep Husted's 350 lifetime climbs.

The summit of Longs Peak is shown in this HHT postcard, mailed August 5, 1919. It describes an itinerary for a forthcoming climb. "Bill Dings is going to guide us up the peak tomorrow," the sender writes. "We go up to Timberline tomorrow morning to stay all night there. Start for the peak Tuesday morning at 6 o'clock. Bill is a licensed guide and supposed to be very good."

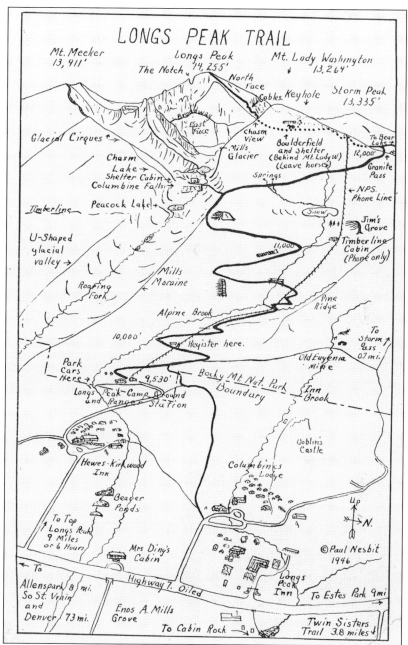

This postcard shows a drawing of the Longs Peak Trail and associated landmarks of the Tahosa Valley, including the Longs Peak Inn, Columbine Lodge, and Hewes-Kirkwood Inn. The card was produced in 1946 by Paul Nesbit, a Longs Peak guide who made his first ascent in 1924 and provided summer guide services for the Longs Peak Inn from 1925 through 1928. Other points of interest on the card include a telephone line at Timberline Cabin; the Boulder Field and its shelter, where horses were to be left; and the site of the old Eugenia Mine, which operated from 1905 to around 1912. The back of the postcard features a drawing of the west and south sides of Longs Peak. The card also includes this warning: "Consult the National Park Service before attempting to climb the East Face of Longs Peak or making any irregular or out-of-season climb."

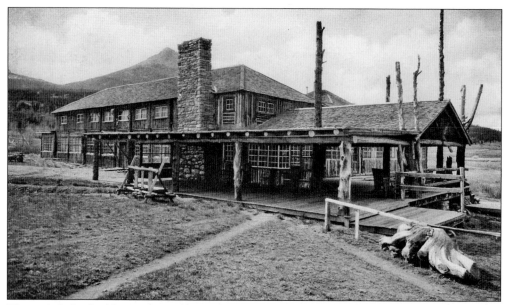

The main lodge building at Longs Peak Inn was built by Enos Mills in 1906 using native materials. Before Mills became a noted author and lecturer, he was running an inn on the property after acquiring the land from Elkanah Lamb, a distant family member, in 1902. The lodge building featured on this W.T. Parke card replaced the original Longs Peak House, which was destroyed by fire in 1906.

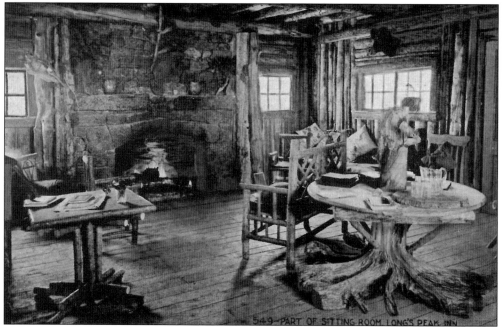

The interior of the Longs Peak Inn was furnished with rustic tables and chairs made from pine and spruce trees. This HHT card shows the sitting room, which includes a table that uses a gnarled tree stump as its base. The fireplace is made of lichen-covered native stone. Despite its rustic appearance, the inn offered all the conveniences of a modern hotel, with electricity, steam heat, and telephone service.

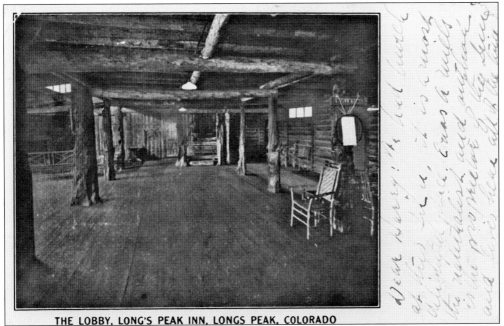

THE LOBBY, LONG'S PEAK INN, LONGS PEAK, COLORADO

This postcard was published by Enos Mills to promote the Longs Peak Inn. The card was mailed in 1919 by a guest who writes, "We had lunch at this inn. It is a most delightful place. Enos A. Mills, the naturalist and author, is the proprietor of the inn and lives here all the time. I hate to leave here. The mountains are wonderful and well named Rocky."

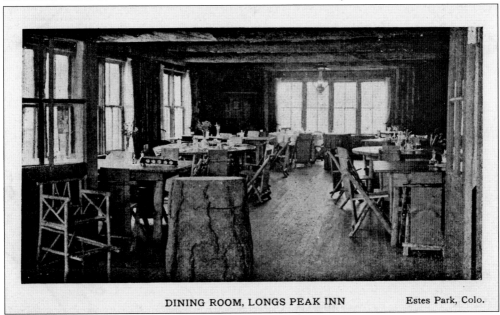

DINING ROOM, LONGS PEAK INN Estes Park, Colo.

This dining room postcard bears a 1911 Longs Peak postmark. In 1909, the Longs Peak Inn served as the post office for the Tahosa Valley, following appointment of Enos Mills as postmaster. The inn had strict protocols. There was no tipping in the dining room and guests were forbidden from playing cards or dancing. Instead, they were encouraged to enjoy the outdoors or attend a nature talk presented by Mills.

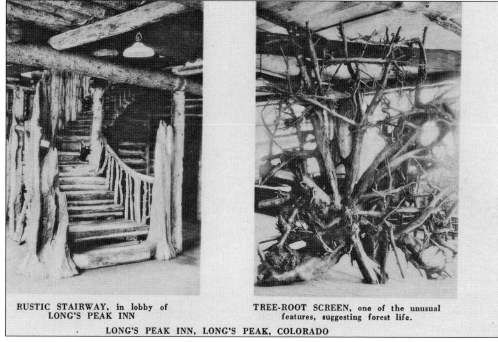

RUSTIC STAIRWAY, in lobby of
LONG'S PEAK INN

TREE-ROOT SCREEN, one of the unusual
features, suggesting forest life.

LONG'S PEAK INN, LONG'S PEAK, COLORADO

The split-log stairway was anchored by newel posts that had been burned in "an ancient forest fire," according to a Longs Peak Inn pamphlet. The spindles were gathered at the timberline. Another unusual feature was the fire screen made from a gigantic upturned tree root recovered from the area, which resembled a spider web. The main lodge building housed a post office, bookshop, recreation room, tearoom, and dining room.

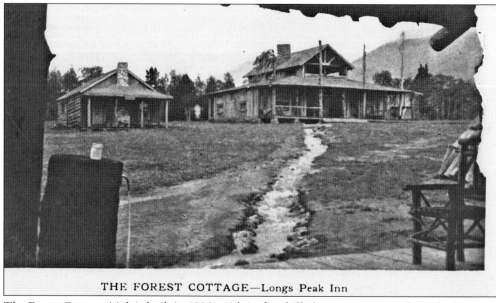

THE FOREST COTTAGE—Longs Peak Inn

The Forest Cottage (right), built in 1908, with its fire-killed trees projecting through the porch roof, is about all that remains of the rustic-style architecture on the property today after fire destroyed the main lodge building in 1949. Later, a new inn was built with a Swiss village theme that is now owned by the Salvation Army and its High Peak Camp.

90

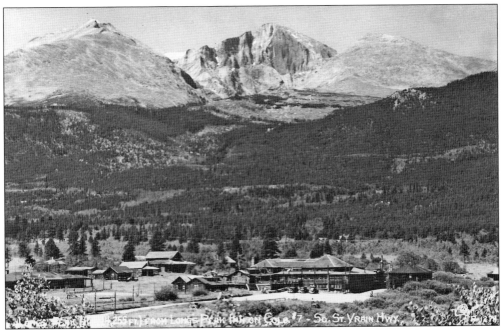

This postcard shows the park's highest peak, with Mount Meeker on the left and Lady Washington on the right. The inn served as a starting point for ascents to the summit of Longs Peak and supplied guides and horses for the seven-mile journey, sometimes led by Enos Mills. He died in 1922, and his wife, Esther, continued to operate the inn until 1945.

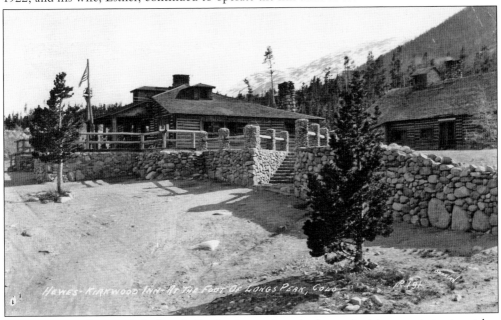

Mary Kirkwood entered the hospitality business when she began inviting guests to stay at her family homestead in the Tahosa Valley. With help from sons Charles and Steve Hewes, the business was expanded around 1914 and became the Hewes-Kirkwood Hotel Ranch and Store. This postcard was mailed from a summer employee who writes, "We sell more peanuts than anything else because people buy them for the chipmunks."

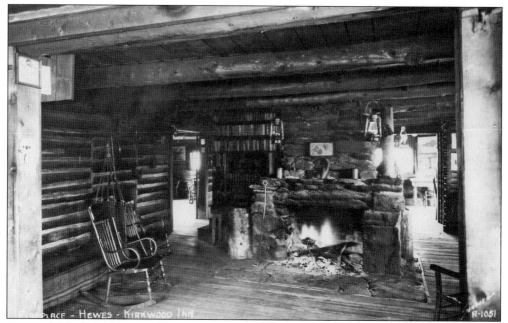

The fireplace at the Hewes-Kirkwood Inn was legendary. The sender of this postcard shares the following account: "It has been burning continuously for 37 years (really just 31 years as it went out once when he had gone to town and couldn't get back)." The writer is referring to Charles Hewes, who operated the inn until 1945. Since the 1950s, it has been home to the Rocky Ridge Music Center.

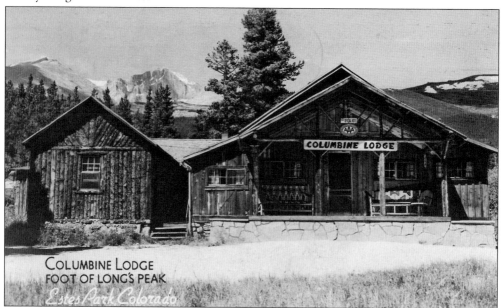

Another nearby inn was the Columbine Lodge, built around 1909 by Harry Bitner. Here, lodge owners preferred to call their neighborhood the Elkanah Valley. Elkanah is a reference to early resident Elkanah Lamb. Ironically, Lamb relative Enos Mills fiercely opposed the name and successfully lobbied government officials to accept his naming suggestion of Tahosa. This postcard was mailed in 1951 and shows the reception hall, also called the main lodge.

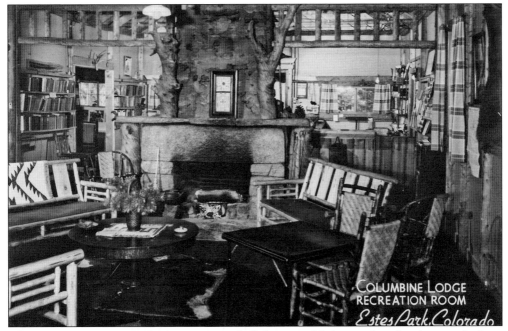

The recreation room inside the reception hall features this interesting fireplace made from native stone and a pair of decorative tree sculptures accenting the mantle. The room is furnished with rustic chairs and other seating. These postcard images are repeated in a 1950s brochure for Columbine Lodge under the ownership of Zora Greenwood. Another proprietor, Charles H. Alexander, owned and operated the property from about 1916 to the mid-1940s.

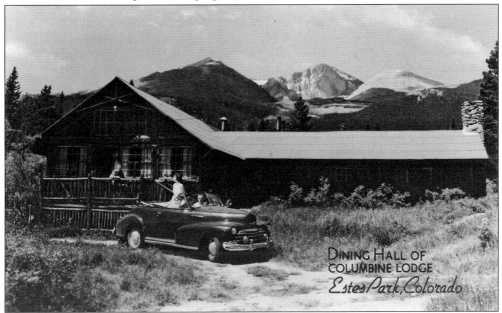

This view of the dining hall of Columbine Lodge provides an impressive glimpse of Mount Meeker, Longs Peak, and Mount Washington. The lodge was within walking distance from the "wildest and most rugged scenery of the region," according to a pamphlet produced by Charles Alexander. The dining hall offered "first-class regular table service as well as chicken dinners."

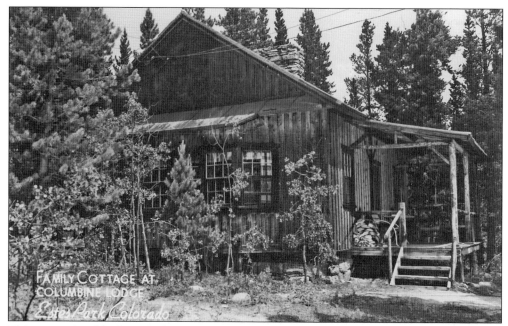

Thirty comfortably furnished cottages were included on the grounds, with a capacity of 80 guests. The cottages ranged in size from one to nine rooms and were located in a grove of pine and aspen trees with a mountain stream running through it flanked by an abundance of wildflowers. Columbine Lodge is now owned and operated by the Salvation Army and is called High Peak Camp.

This postcard shows a bed of columbines, from which the lodge took its name. The sender of the postcard from 1951 writes, "The columbines in abundance around the lodge are glorious. The views magnificent." The columbine was designated as the official state flower of Colorado in 1899, following a vote by the state's schoolchildren.

94

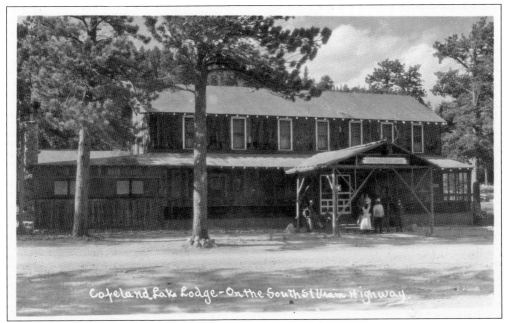

Copeland Lake Lodge was opened about 1914 by Burns Will, a Boulder County commissioner. The land was part of a ranch homesteaded by John B. Copeland. This 1920s postcard shows the rustic two-story lodge. It was built near the present southeast entrance station to Rocky Mountain National Park, known as Wild Basin, and was accessed from State Highway 7, south of Estes Park.

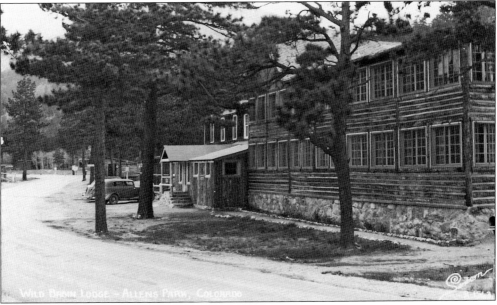

This later postcard shows a new name for the property, Wild Basin Lodge, and a new wing. Additional expansions provided accommodations for 125 guests in the lodge, with room for another 100 guests in housekeeping cabins. A fire destroyed the original lodge building in the early 1980s. It was rebuilt the following year in a new location and is now operated as the Wild Basin Lodge and Event Center.

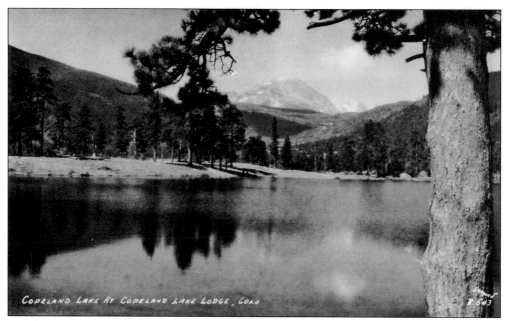

Copeland Lake, with Mount Copeland in the distance, is a man-made lake that was built on the Copeland homestead. The lake has provided guests with convenient fishing access over the years. Other amenities and activities promoted by the lodge included square dancing, stables, ponies, mountain climbing, hiking, and chicken dinners.

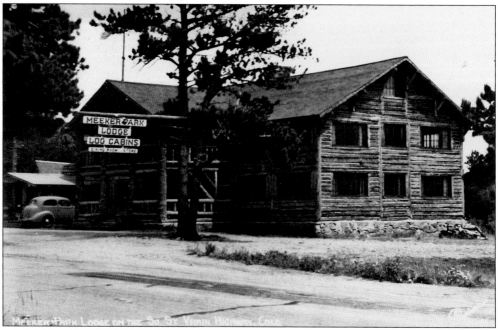

Meeker Park Lodge is another of the roadside inns along the scenic Peak to Peak Highway 7 between Estes Park and Allenspark. Located at the foot of Mount Meeker, elevation 13,911, and adjoining Rocky Mountain National Park, the lodge was built in the 1920s by two families from nearby Longmont—Gay and Leota Nowels, and Danny and Crete Dever. It remains a family-run operation today, with Dever relatives taking over ownership.

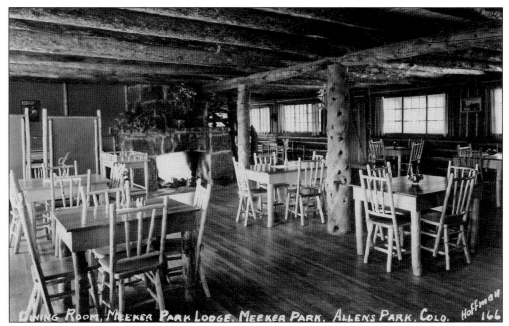

Known for its Western hospitality, many loyal guests returned year after year at Meeker Lodge. This Hoffman postcard was mailed in 1937 and shows the lodge dining room with its log beams and relaxing fireplace along the back wall. A lounge occupied the other side of the room. Cabins, gas pumps, and a small store were also included on the grounds. Stables were operated nearby.

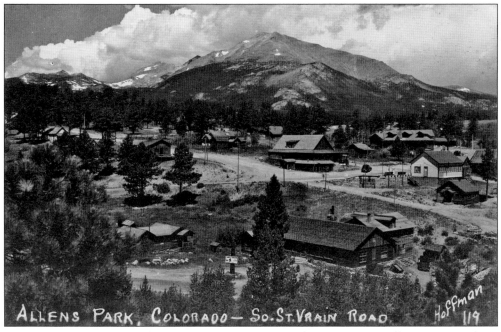

Farther south along the Peak to Peak Scenic Byway is Allenspark, the small community about 15 miles from Estes Park. Guest accommodations included Crystal Springs, the Fawn Brook Inn, and the Isle Trading Post, which is located on the top right of this Hoffman card with the snow-covered Mount Meeker in the distance.

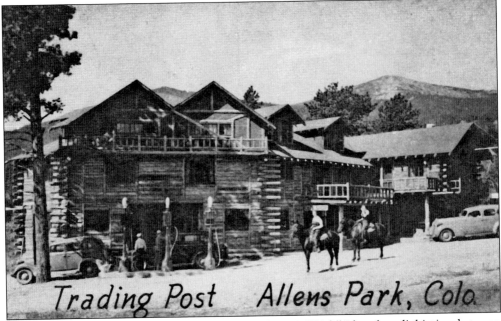

The Trading Post Lodge was built in the early 1930s by R.J. "Dick" Isle, who split his time between Allenspark and Longmont. This postcard was mailed in 1952 and promotes "complete tourist accommodations" with a "modern lodge, modern cabins, store, gift shop, saddle horses, dining room and lunch room." It is operated today as a bed-and-breakfast and is called Allenspark Lodge.

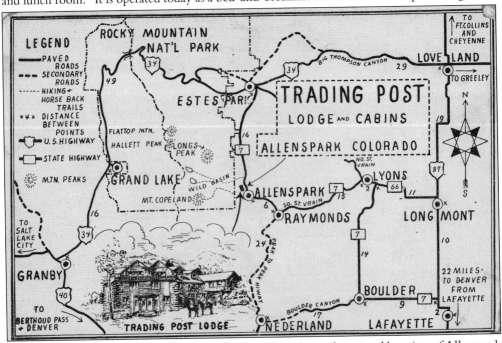

This postcard, published by the Isle family in the 1950s, shows the central location of Allenspark and the Trading Post Lodge in proximity to local attractions, including the Wild Basin area of Rocky Mountain National Park, where hikes to Lily Mountain, Copeland Falls, Ouzel Falls, Eugenia Mine, and Estes Cone were popular outings.

Six

EARLY SIGHTSEEING AND RECREATION

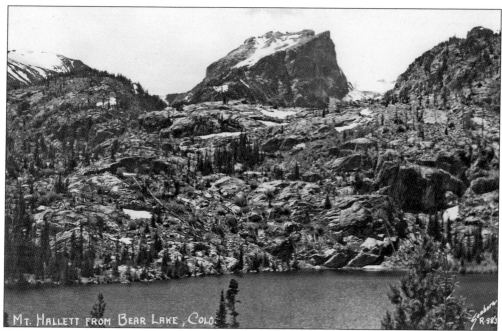

Bear Lake became a favored destination in Rocky Mountain National Park following completion of a new access road in the 1920s. The picturesque setting is ringed by the highest mountains in the park, including Hallett Peak. At an elevation of about 12,712 feet, the jagged peak is among the park's most recognizable mountains. It was named for William Hallett, who helped establish Colorado's first mountaineering club in 1896.

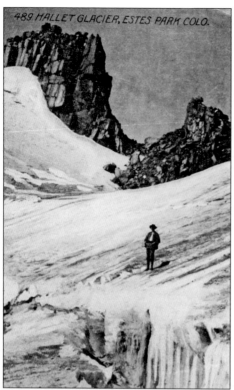

William Hallett was also responsible for bringing attention to the first glacier identified in Colorado. This HHT postcard describes the glacier as one of the chief attractions in Rocky Mountain National Park. One of only a handful of visible glaciers still existing in the park, it was renamed Rowe Glacier in the 1930s to avoid confusion with Hallett Peak and to recognize its discovery by Israel Rowe while bear hunting in the 1880s.

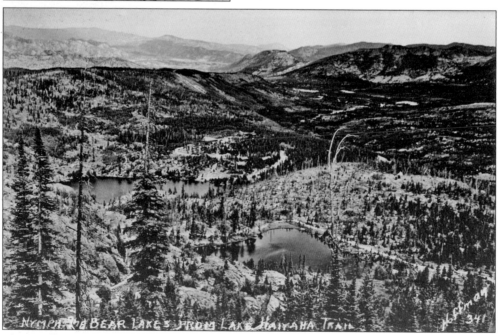

This Hoffman card shows an overhead view of Bear Lake (left) and nearby Nymph Lake from the Lake Haiyaha Trail. The aftermath of a large forest fire that took place about 1900 and swept through the Glacier Gorge area is visible. Bear Lake was the site of an early tent camp that evolved into Bear Lake Lodge. Several of the lodge buildings can be seen.

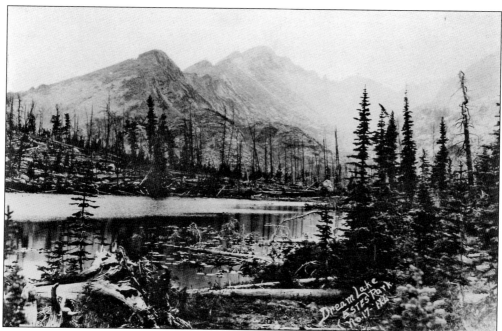

Dream Lake, at an elevation of approximately 9,420 feet, is another of the picturesque lakes that can be found about a mile above Bear Lake as it winds along the Lake Haiyaha Trail. Situated at the base of Mount Hallett, the lake also offers views of Longs Peak, as shown on this c. 1900 postcard marked "IXL." From here, the trail climbs another 150 feet to reach Emerald Lake.

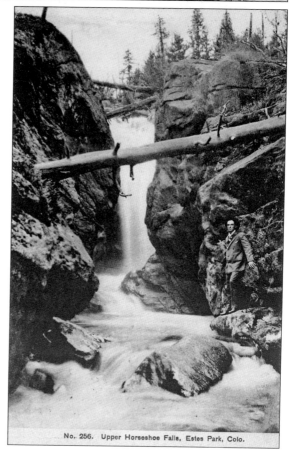

No. 256. Upper Horseshoe Falls, Estes Park, Colo.

Described as one of the prettiest waterfalls in Rocky Mountain National Park, Horseshoe Falls, now known as Chasm Falls, is shown on this c. 1910 W.T. Parke postcard. The image has been altered by the placement of a man on the right. The sender of the card was among its many admirers and writes, "This fall was beautiful. As to scenery, I think we have it here. We are enjoying ourselves immensely, camping with peaks all about us."

PANORAMA OF HORSESHOE PARK AND THE MUMMY RANGE, COLO.

The serenity of Horseshoe Park is shown in this postcard; this area had bustled with activity when dignitaries gathered for the 1915 dedication of Rocky Mountain National Park. The distinctive U-shaped valley was formed by glaciers and includes stunning views of the Mummy Range. Elk, bighorn sheep, and other wildlife have also gathered here. The Horseshoe Inn can be seen in the distance along Fall River Road. (Courtesy Bobbie Heisterkamp Collection.)

Ousel Falls, Grand Lake, Moffat Road, Colo.

This postcard, issued by the Colorado News Company and mailed in 1908, shows the rushing waters of Ousel Falls, located along the East Inlet trailhead on the west side of Rocky Mountain National Park near Grand Lake. The falls were renamed Adams Falls in honor of Jay E. Adams. He was among the first settlers to build a lakeshore home on Grand Lake in the 1880s.

The gnarled pine tree in this postcard became a famous landmark as visitors entering Rocky Mountain National Park from High Drive stopped to take a closer look. The lone pine became the subject of numerous photographs during its existence, including this postcard mailed in 1924. The ponderosa eventually succumbed to souvenir abuses and died in the late 1940s. It was toppled by a windstorm in 1950.

Interesting rock and mountain formations were the subjects of numerous postcards. This Hoffman card shows how Longs Peak (center) is used to illustrate the profile of "the Chief." Chiefs Head Peak (left), at an elevation of 13,579 feet, is the third-highest peak in Rocky Mountain National Park. The Estes Cone (right) completes the profile as seen in this view from the southeast.

No. 2023 Hanging Rock, Estes Park, Colo.

This unusual outcropping was located on the original road through the Big Thompson Canyon near Drake. In this Great Western postcard, the outcropping is identified as Hanging Rock. It was also known as Sheeps Head Rock and became the subject of many photographic images before the rocks gave way in 1910. (Another example is on page 12.)

Another interesting rock formation is the Twin Owls, located on the southeast side of Lumpy Ridge in Rocky Mountain National Park. Together, these iconic granite landmarks, as pictured in this HHT postcard, form the shape of owls, spanning two hundred feet, sitting on a perch. This is the one of most recognizable rock formations within the park and is visible from many areas of Estes Park. (See also page 54.)

486 THE OWLS, ESTES PARK, COLORADO.
ROCKY MOUNTAIN NATIONAL PARK.

Chief Colorow is the name of this rock formation, which became a noted point of interest along Fall River Road at Milner Pass. This postcard by F.J. Francis shows how the rock formation bears a striking a resemblance to a Native American chief looking down over the Kawuneeche Valley. Chief Colorow was the leader of the White River Utes. (Courtesy Bobbie Heisterkamp Collection.)

CHIEF COLOROW, FALL RIVER ROAD
F. J. FRANCIS R. M. NATIONAL PARK ESTES PARK, COLO.

Dozens of trout are displayed in this HHT postcard, which boasts the end of a perfect day. The description on the back of the card identifies Rocky Mountain National Park as the "true fisherman's paradise," with an abundance of brook trout, speckled trout, and rainbow trout. The description continues with the affirmation, "Here is found some of the best fishing in Colorado, which means the best fishing in the world."

91021. "End of a Perfect Day," in Rocky Mountain National Park.

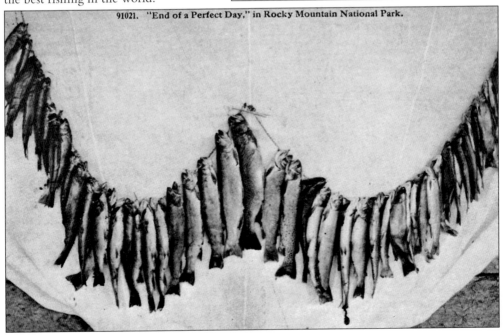

To ensure that area streams would be well stocked for the annual influx of visitors, a fish hatchery was developed by the Estes Park Protective and Improvement Association with funds raised from the community. The hatchery opened in 1907 and was located near the Fall River on the way to Horseshoe Park. This P.C. Company postcard shows the hatchery building. The grounds included a series of concrete and earthen holding ponds.

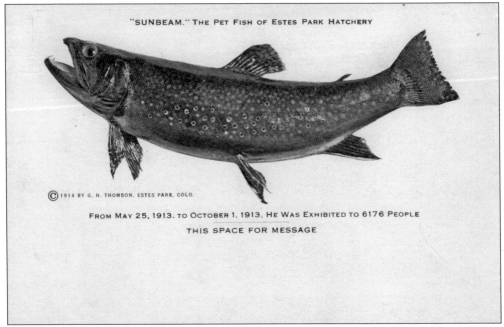

In 1913, the fish hatchery had a capacity of one million eggs, adding 600,000 fish to area streams. The hatchery was run by the affable Gaylord H. Thompson, who entertained visitors with his pet trout Sunbeam for many years. Leased by the state, operations continued until 1982, when the facility was destroyed by the Lawn Lake Flood. (Courtesy Bobbie Heisterkamp Collection.)

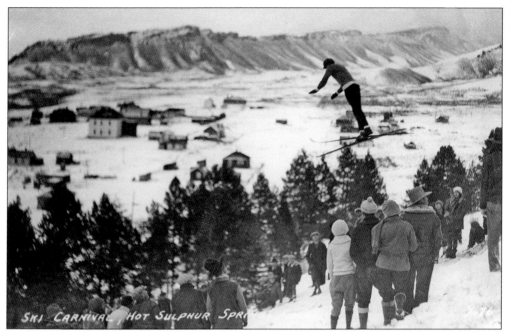

Colorado's winter sports movement got its start in 1911, when townspeople in Middle Park's Hot Sulphur Springs organized the first winter carnival west of the Mississippi. It became an annual affair, with ski jump exhibitions introduced by Norwegian Carl Howelsen and other competitions enjoyed by spectators. This postcard, mailed in 1930, identifies a jumper from Chicago as setting the hill record of 129 feet. (Courtesy Grand County Historical Association.)

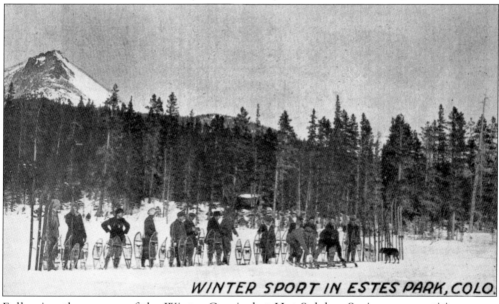

Following the success of the Winter Carnival at Hot Sulphur Springs, competitions were organized in Estes Park. Members of the Denver-based Colorado Mountain Club helped propel the attraction for winter sports with sponsored outings to Fern Lake. The Outdoor Club of Estes Park was also involved in winter promotion by helping to create a skating pond and a toboggan run on Prospect Mountain. This postcard was produced by W.T. Parke.

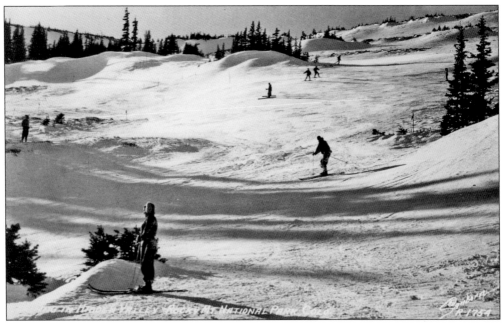

Skiing and tobogganing at Hidden Valley on the east side of Rocky Mountain National Park were favorite attractions in the decades before the ski area operation was awarded to a concessionaire in the 1950s. With four trails and three lifts, the ski area was run by the James family, who provided infrastructure investments for more than 20 years. It was closed in 1992. (Courtesy Bobbie Heisterkamp Collection.)

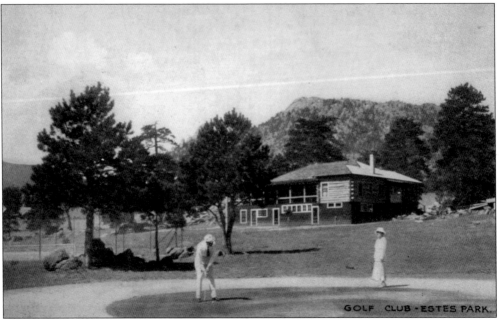

An investment group known as the Estes Park Golf and Country Club was responsible for creating the first golf course, which opened in 1917. The course featured 18 holes with greens originally made of sand. The country club building shown on this W.T. Parke postcard was built in 1916 and is still in use. (Courtesy Bobbie Heisterkamp Collection.)

Seven

MOUNT CRAIG AND GRAND LAKE

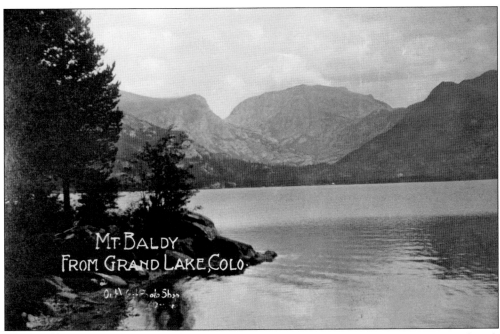

MT. BALDY
FROM GRAND LAKE, COLO.

One of the most photographed scenes from the west side of Rocky Mountain National Park is this one showing "Mt. Baldy" as it rises above the waters of Grand Lake, the largest natural body of water in Colorado. The rounded, mostly treeless mountain is located within the park boundaries and is officially known as Mount Craig, elevation 12,007 feet. The postcard was published by Out West.

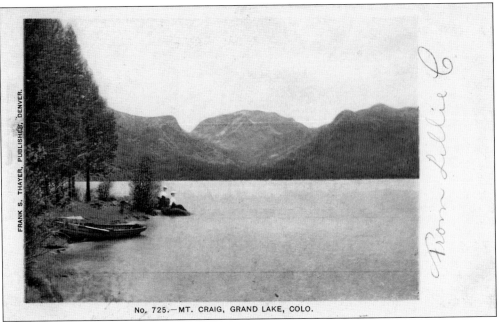

No. 725.—MT. CRAIG, GRAND LAKE, COLO.

Mount Craig is named for William Bayard Craig, a Denver pastor who acquired lakeshore property during his visits to Grand Lake in the 1880s. Named Craig's Point, the property is pictured in this Thayer card postmarked 1909. Many of the early residents called the mountain "Wescott" in honor of Grand Lake's first settler, Judge Joseph Wescott, whose name was eventually bestowed on the mountain to the south of Mount Craig.

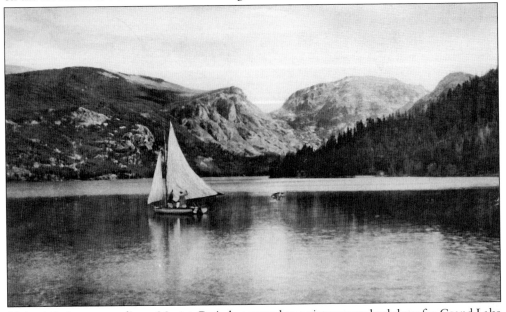

Majestic in its surroundings, Mount Craig has served as a picturesque backdrop for Grand Lake water sports, which began in the early 1900s when makeshift sailboats were fashioned from rowboats and bed sheets. The first authentic sailboat was introduced on Grand Lake in 1903. Since then, numerous postcards have been produced showing the boats gliding across the lake, as illustrated by this J.B. Baird postcard.

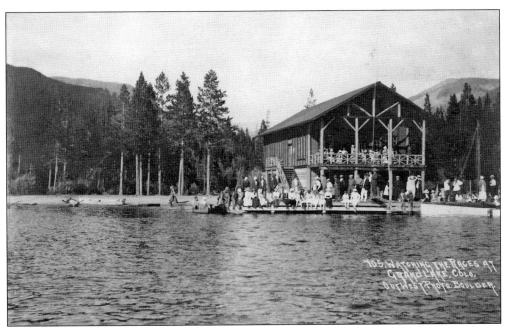

The Grand Lake Yacht Club was established in 1902 as the highest registered yacht club in the world. It was chartered by three sailing enthusiasts who had built summer homes on the west shore of the lake. The clubhouse was built in 1912 on the lake's north shore. Two years earlier, club representatives had invited British yachtsman Sir Thomas Lipton of the legendary tea company to a dinner in Denver and convinced him to present one of his coveted Lipton Cups to the emerging club. The distinctive cup was given to the Grand Lake Yacht Club in 1913 and continues to be presented annually. These postcards, published by Out West Photo Shop of Boulder, show spectators gathered around the newly built clubhouse and the beach to watch a boat race on the lake.

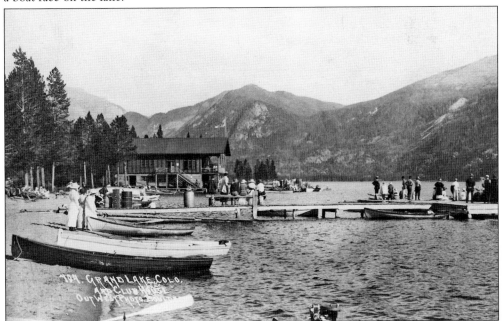

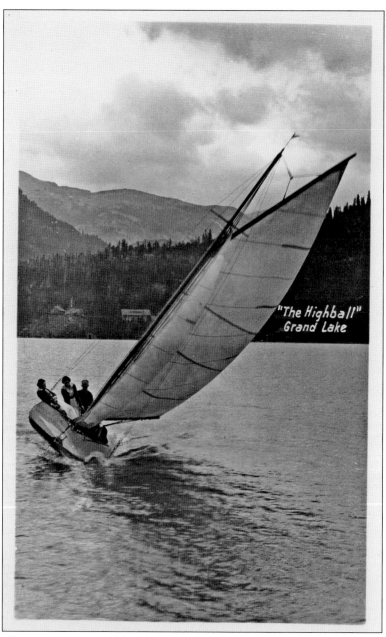

"The Highball" Grand Lake

The first sailboat race sponsored by the Grand Lake Yacht Club was held in 1903 with two competitors. The boats—*Dorothy II*, owned by Commodore William Henry Bryant, and *Highball*, owned by Thomas Patterson Campbell—provided head-to-head competition, with *Dorothy II* winning the inaugural Colorado Cup race. *Highball*, which is pictured in this postcard, went on to take first place during the second, fourth, and fifth years of the race. The competition continued between the two boats with one or the other taking the cup until 1915, when another yacht took first place. The sailing tradition has continued throughout the decades, as club members return each August during Regatta Week to compete for the coveted Lipton Cup and other trophies. To sustain the tradition into the future, a sailing school for youth was established in the 1970s. (Courtesy Bobbie Heisterkamp Collection.)

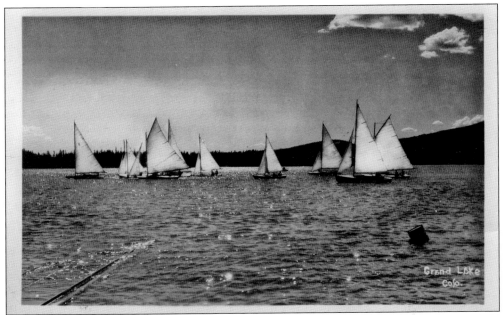

This postcard shows a cluster of sailboats racing on Grand Lake during Regatta Week, held annually in August. During the races, sailboats maneuver from one side of the lake to the other and back around marked buoys. Many fifth-generation families are now involved in the sport today as they compete for coveted cups bearing the names of the lake's first-generation families. (Courtesy Bobbie Heisterkamp Collection.)

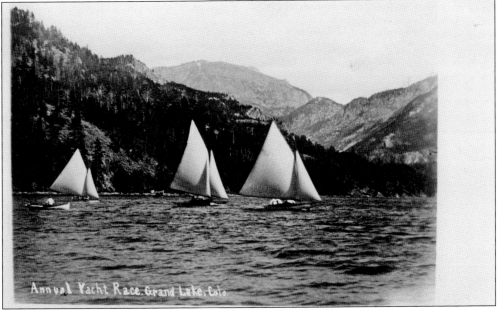

Another scene of a Grand Lake yacht race is shown in this vintage postcard. Races lasted anywhere from 35 minutes to two hours, depending on the wind, and were held regardless of the weather. One of the favorite activities during Regatta Week is the Venetian Night Parade, in which elaborately decorated boats pass by a reviewing stand, with a prize awarded for the best boat. (Courtesy Bobbie Heisterkamp Collection.)

This Hildreth postcard, mailed in 1909, shows the east shoreline of Grand Lake with a large boathouse on the left at Adam's Beach. The sender writes, "I have just purchased 100 feet of lakefront where you see the pagoda on rocks for a summer home." At the time, Jay E. Adams owned 200 acres on the lake's southeast side and had subdivided the property to include 60 lakefront lots.

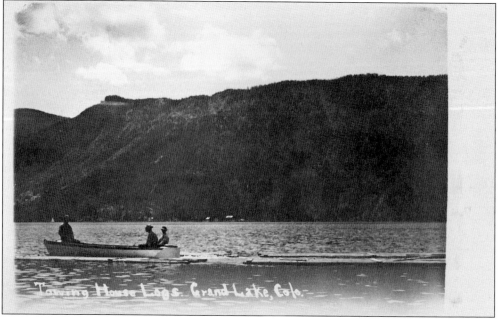

With limited access to the building sites, materials to construct many of the lakeshore homes were transported by boat, as illustrated in this early postcard. The homes were made of native materials, with rooms that featured hand-peeled logs and stone fireplaces with bark-sided slab treatments on the exterior. The summer home intentions described in the previous postcard did not materialize until years later.

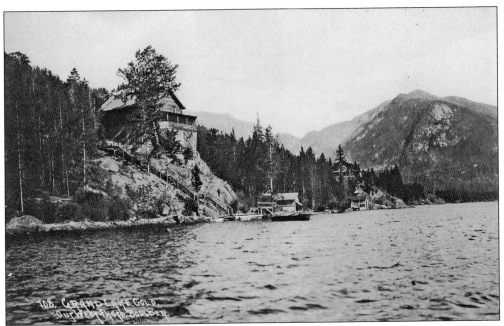

Located on the north shore of Grand Lake, this summer home is featured on a postcard made by Out West Photo Shop of Boulder due to its interesting placement on top of a rock formation overlooking the lake. The home was owned by the J.R. Ives family; Ives was commodore of the Grand Lake Yacht Club in 1923. The home remains an interesting sight even today.

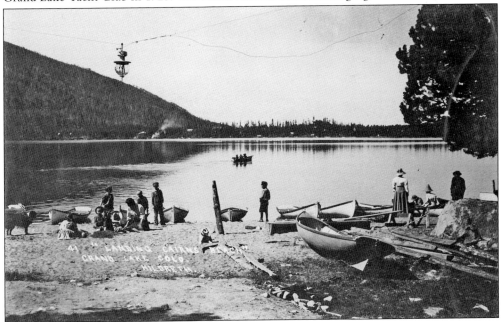

Children enjoy playing in the sand at the Cairns beach landing in this c. 1910 Hildreth postcard. This is the site of the current public beach area on the north side of Grand Lake. The Cairns name comes from early Grand Lake businessman James Cairns, who erected the first store in the newly platted town in 1881. A lamp has been rigged above the beach area to provide nighttime lighting.

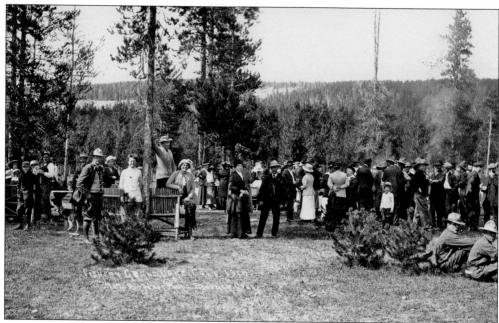

A fish fry along the north shore of Grand Lake is shown in this Out West postcard dated 1916. Outings like these, as well as dances, boat races, and rodeos, were enjoyed by community members of all ages, including a growing number of summer residents. Many of these seasonal residents came from the Midwest and looked forward to spending their summers enjoying the cooler temperatures. (Courtesy Grand County Historical Association.)

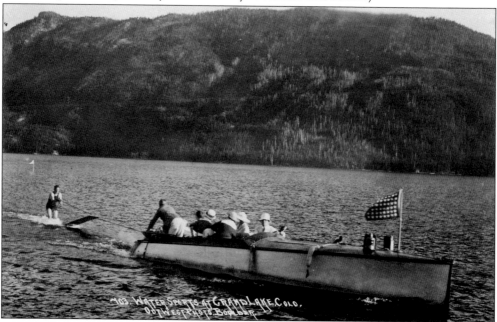

An early form of water-skiing on Grand Lake is pictured on this 1920s postcard, published by Out West Photo Shop. It shows a young man being pulled behind a boat while balancing on a wooden board. Earlier, membership in the Grand Lake Yacht Club had been extended to motorboat and rowboat owners to help fund construction of the clubhouse.

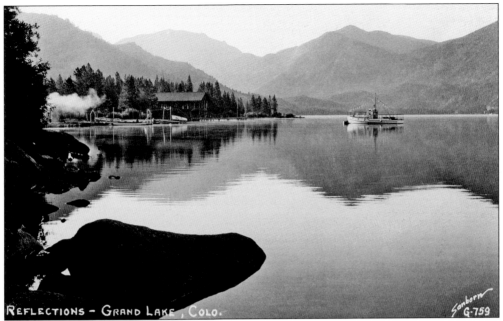

Commercial boat tours have been part of Grand Lake's history for more than a century. This postcard shows *Micky*, a 40-foot touring steamboat that was operated for years by Grand Lake Boat Service, owned by Louise Millinger. Her father, Capt. W.J. McCarty, had started the business when he brought a fleet of motorboats and canoes to Grand Lake over Berthoud Pass around 1909. (Courtesy Grand County Historical Association.)

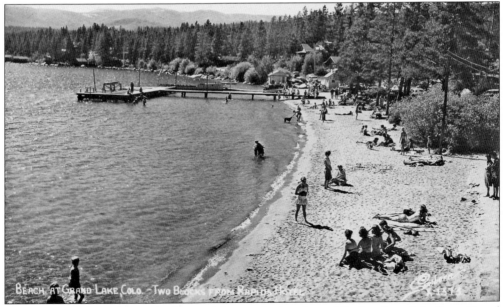

This postcard from the 1950s shows visitors enjoying the public beach and dock on Grand Lake's north shore during a warm summer day. The scene shows sunbathers, swimmers, waders, fishermen, and picnickers taking part in a variety of summer rituals at an elevation of 8,367 feet. The postcard was used by the Rapids Hotel to promote its proximity to the beach and to downtown Grand Lake.

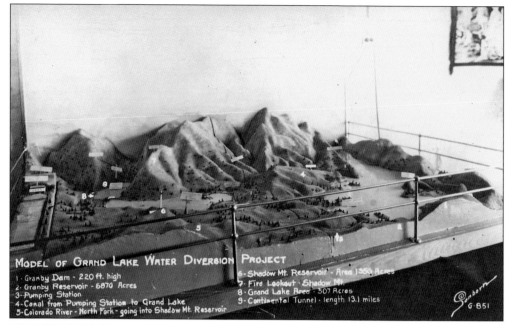

MODEL OF GRAND LAKE WATER DIVERSION PROJECT

1 - Granby Dam - 220 ft. high
2 - Granby Reservoir - 6870 Acres
3 - Pumping Station
4 - Canal from Pumping Station to Grand Lake
5 - Colorado River - North Fork - going into Shadow Mt. Reservoir

6 - Shadow Mt. Reservoir - Area 1350 Acres
7 - Fire Lookout - Shadow Mt.
8 - Grand Lake Area - 507 Acres
9 - Continental Tunnel - length 13.1 miles

G-851

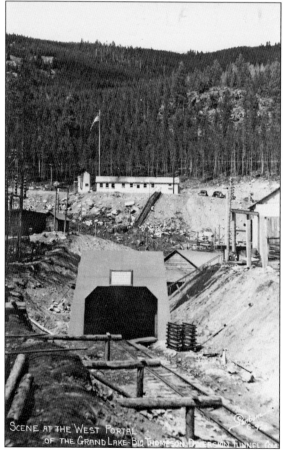

SCENE AT THE WEST PORTAL
OF THE GRAND LAKE - BIG THOMPSON DIVERSION TUNNEL

Grand Lake's notable water history is represented in this postcard showing a model of the Grand Lake Water Diversion Project, part of the Colorado Big Thompson Project. Water from the Colorado River is delivered to the eastern slope through a 13-mile-long tunnel beneath the Continental Divide. It was named for Alva B. Adams, US senator from Colorado. Construction began in 1940 with crews working simultaneously from both sides.

This postcard shows the West Portal construction scene on the northeast side of Grand Lake as the diversion project nears completion. Construction crews spent four years drilling the Alva B. Adams Tunnel. When the two crews met in the middle in 1944, they were off by less than the width of a penny. Water began flowing in 1947. The tunnel is maintained by the US Bureau of Reclamation.

Eight

THE GATEWAY VILLAGES OF ESTES PARK AND GRAND LAKE

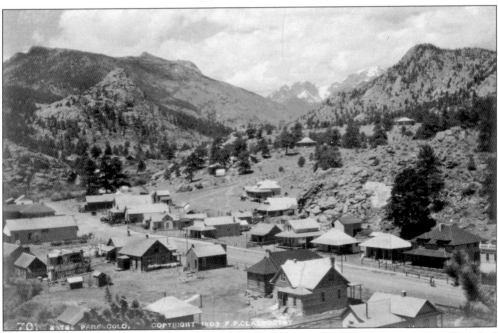

Located at the confluence of the Fall and Big Thompson Rivers, the village of Estes Park had its beginnings with the 1880s construction of a schoolhouse and other buildings on land later acquired by John Cleave in 1890. This included a new location for the post office, where Cleave served as postmaster. By 1907, when this Clatworthy postcard was produced, more buildings had been added to fulfill the growing tourism needs.

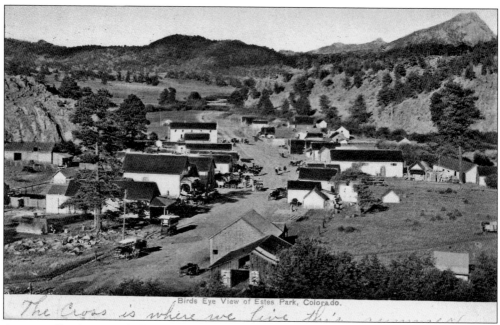

A group of businessmen led by Cornelius H. Bond, known as the Estes Park Town Company, led the effort to plat the town after acquiring the property from John Cleave in 1905. The company offered up more than 250 lots for sale. This W.T. Parke postcard, mailed in 1907, shows the beginning of the new town in a view looking east down Elkhorn Avenue.

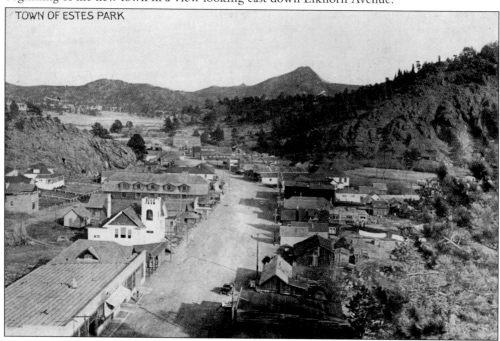

This same view from a W.T. Parke postcard mailed in 1921 shows the Presbyterian church on the left, built in 1909. East of the church is the Sherwood Hotel with its distinctive dormer windows. It was destroyed by fire in 1956. The large building on the left with the flat roof is the Osborn Garage. The sender of the postcard writes, "This is the prettiest place we ever saw."

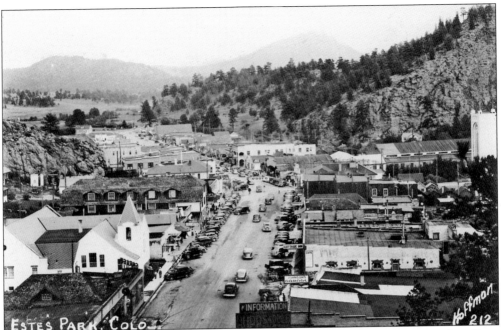

The view looking east is repeated in this Hoffman postcard from 1946, which shows the village bustling with activity along with the rise in automobile travel. Cars are shown parked in front of the many businesses along Elkhorn Avenue. By now, the Presbyterian church has a new steeple, and the tallest building in the village can be seen on the right, the Park Theatre, with its tower added in 1929.

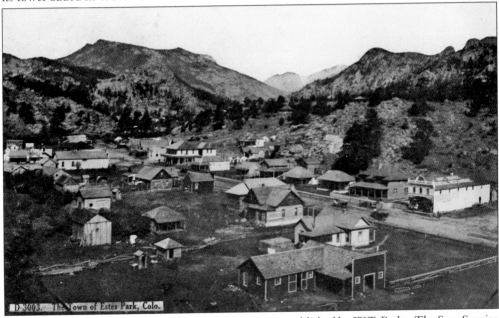

This c. 1910 scene of Estes Park taken from the west was published by W.T. Parke. The Sam Service General Store is pictured on the far right. It opened in 1906 with the family residence located next door. Another prominent building can be seen at the top of the street on the right. This is the Hupp Hotel, formerly Manford Hotel. The storefront east of the hotel is Parke's Studio.

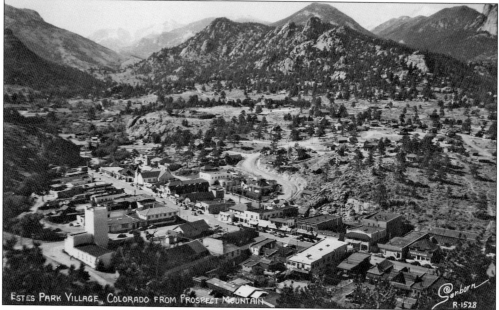

A similar view is shown in this postcard from Prospect Mountain, mailed in 1948, showing the later stages of the town's development, in which the Lewiston Hotel is noticeably missing from the hillside. The Sam Service residence has become a retail store. The building to the west is the bowling alley. Estes Park was incorporated as a town in 1917, and many of the early buildings remain in use today.

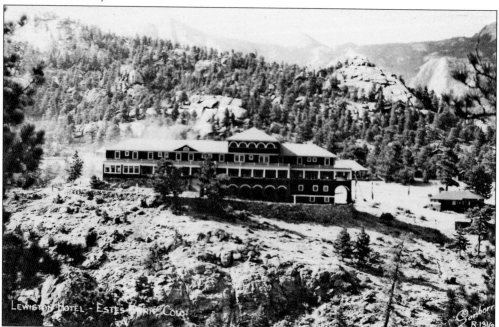

This postcard shows one of the last views of the Lewiston Hotel before it was destroyed by fire in 1941. The Lewiston, which rivaled the Stanley Hotel in its grandeur, overlooked the village on the south side. The property was converted from a private residence to a hotel following several additions that began about 1915. It was built and operated by hotelier A.D. Lewis.

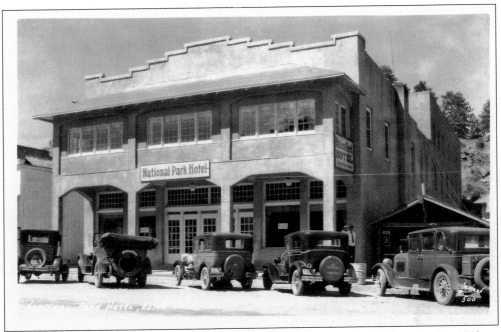

Another downtown lodging property was the National Park Hotel, which opened in 1919 on Elkhorn Avenue. It was operated by Harriet Byerly and continued to run as a family business until the 1970s. After its use as a hotel, it became a Ripley's Believe It or Not! Museum. Today, the building houses a variety of retail shops.

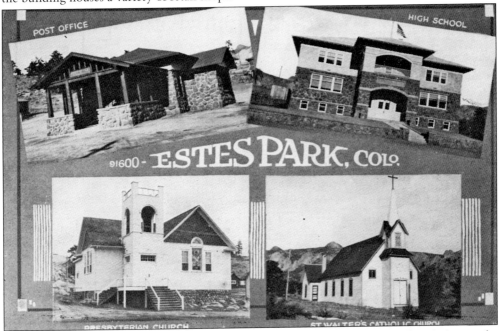

This HHT postcard was produced to share the community's civic pride. The description on the back boasts, "The Town of Estes Park has developed rapidly within the past few years, and the residents take great pride in their public and church buildings." Estes Park became a town on April 17, 1917, after 73 of 85 voters cast ballots to begin incorporation during an earlier election.

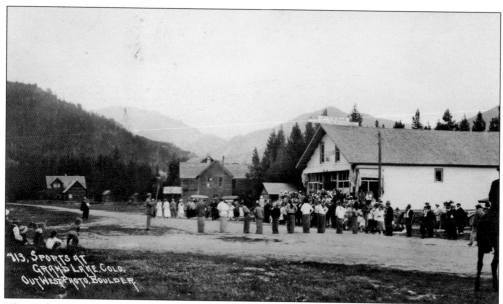

The town of Grand Lake was established in 1881 in its present location following attempts by early settler Joseph Wescott to build "Grand Lake City" on the lake's west shore. In this c. 1910 Out West postcard, a sack race is taking place in front of the recently expanded general mercantile store operated by James Cairns. It was the first building constructed after the new town was platted.

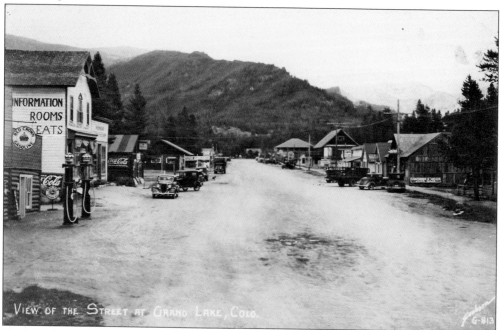

Grand Lake prospered while serving as a supply center for nearby mining towns. When the mining boom collapsed around 1883, the villagers turned to tourism for their future prosperity, relying on the beauty of the surrounding natural resources and eventually serving as the western gateway to Rocky Mountain National Park. This 1930s view looking east shows the tourism-related services offered along the main entry into town.

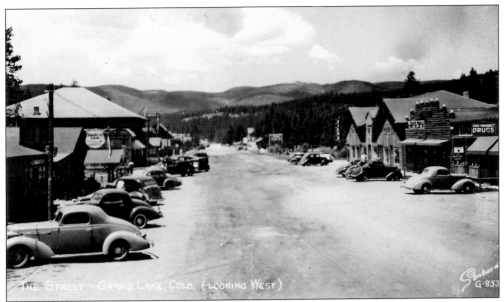

This postcard from the 1940s shows a street scene of Grand Avenue in a view looking west. The businesses on the right include a drugstore, Bill's Café, and Zick's Grocery and Hotel. On the left, a sign for the Iron Kettle Inn hangs out front. Farther down, the largest building on the block is Humphrey's, the site where James Cairns started his mercantile store in 1881. The town was incorporated in 1944.

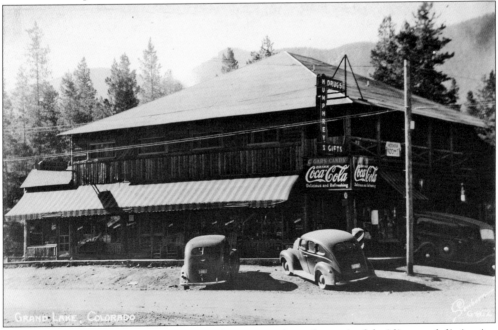

The two-story Humphrey's building, with its covered porch, rustic slab siding, and distinctive neon sign, has been a familiar sight to Grand Lake travelers for decades. The gift shop was operated by Matilda G. Humphrey after acquiring the building in 1924, with operations remaining in the family until the 1990s. This postcard of the business is from about 1940. The building remains in use today as a retail store.

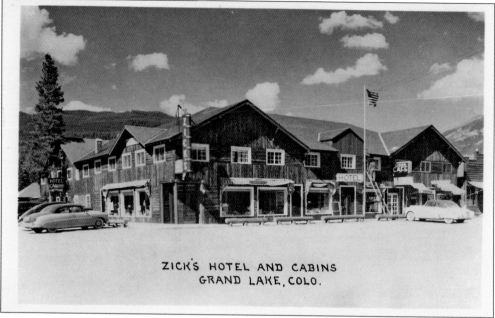

ZICK'S HOTEL AND CABINS
GRAND LAKE, COLO.

Across the street from Humphrey's on Grand Avenue was Zick's Place, a combination hotel, café, and market that opened in 1918. It was operated by the John Zick family and remained a family-run business until the late 1970s. A restaurant is located there today. In the 1880s, the building housed the county courthouse when Grand Lake was the county seat.

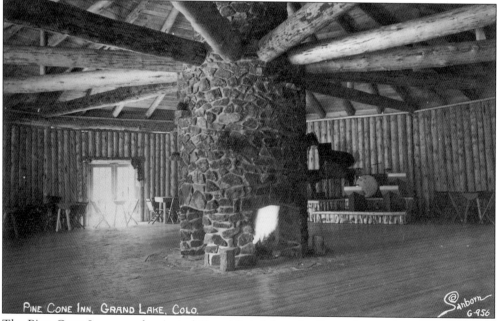

PINE CONE INN, GRAND LAKE, COLO.

The Pine Cone Inn once dominated Grand Lake's boardwalk on the southeast end of Grand Avenue. It was a popular restaurant and dance hall for decades and was home to live theater productions in the 1970s. Rebuilt after a fire in the 1940s, the inn featured this wagon-wheel fireplace, which has since been preserved and is enjoyed by patrons of a bar and restaurant located on the site.

BIBLIOGRAPHY

Arps, Louisa Ward and Elinor Eppich Kingery. *High Country Names.* Boulder: Johnson Printing, 1977 and 1994.

Black, Robert C. III. *Island in the Rockies: the Pioneer Era of Grand County, Colorado.* Granby, CO: Grand County Pioneer Society, 1969.

Cairns, Mary Lyons. *Grand Lake in the Olden Days: A Compilation of Grand Lake, the Pioneers and the Olden Days.* Denver: World Press, 1971.

Clinger, Mic, James H. Pickering, and Carey Stevanus. *Estes Park and Rocky Mountain National Park: Then & Now.* Westcliffe, CO: Westcliffe Publishers, 2006.

Heisterkamp, Bobbie, and James H. Pickering. *Shared Moments Rocky Mountain National Park and Estes Park Remembered in Postcards.* Printed in Canada. Self-published, 2011.

Jessen, Kenneth. *Estes Park Beginnings.* Loveland, CO: J.V. Publications, LLC, 2011.

———. *Rocky Mountain National Park Pictorial History.* Loveland, CO: J.V. Publications, LLC, 2008.

Lindberg, James, Patricia Raney, and Janet Robertson. John Gunn, ed. *Rocky Mountain Rustic: Historic Buildings of the Rocky Mountain National Park Area.* Estes Park, CO: Rocky Mountain Nature Association, 2004.

O'Ryan, Dorothy O'Donnell. *Sailing Above the Clouds: An Early History of the Grand Lake Yacht Club.* Montrose, CO: Western Reflections Publishing Company, 2002.

Pederson, Henry F. *Those Castles of Wood: The Story of Early Lodges of Rocky Mountain National Park and Pioneer Days of Estes Park, Colorado.* Estes Park, CO; Self-published, 1993.

Pickering, James H. *America's Switzerland: Estes Park and Rocky Mountain National Park, the Growth Years.* Boulder: University Press of Colorado, 2005.

Silverthorn, Suzanne. *Rocky Mountain Tour Estes Park, Rocky Mountain National Park, & Grand Lake.* Atglen, PA: Schiffer Publishing, 2008.

Discover Thousands of Local History Books Featuring Millions of Vintage Images

Arcadia Publishing, the leading local history publisher in the United States, is committed to making history accessible and meaningful through publishing books that celebrate and preserve the heritage of America's people and places.

Find more books like this at
www.arcadiapublishing.com

Search for your hometown history, your old stomping grounds, and even your favorite sports team.